The Seasons Observed

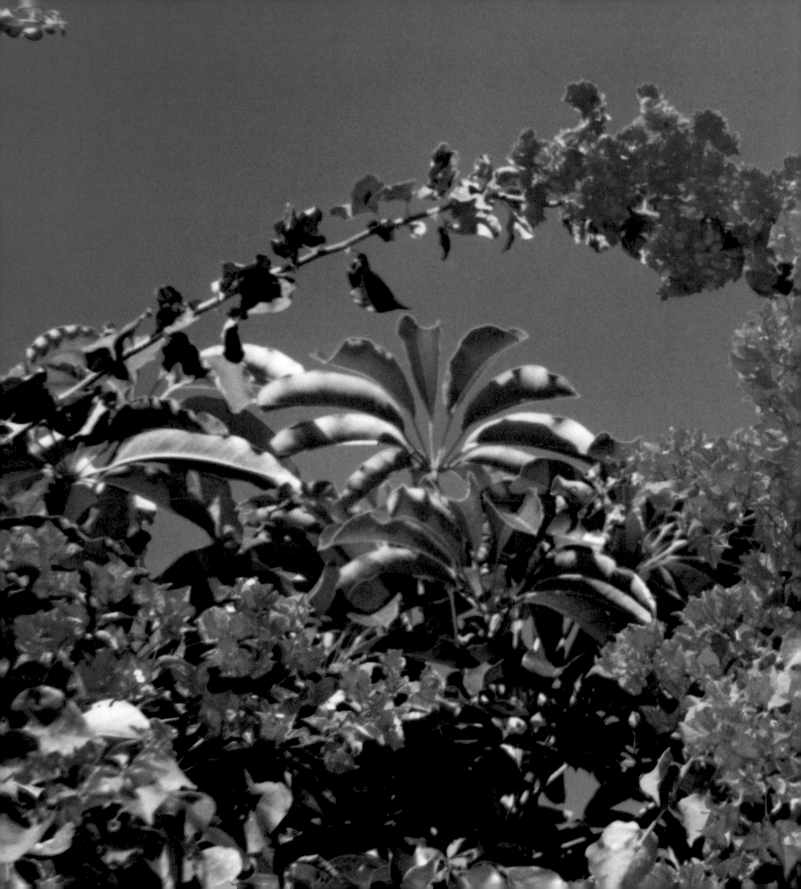

THE SEASONS OBSERVED

PHOTOGRAPHS BY EVELYN H. LAUDER

HARRY N. ABRAMS, INC.,
PUBLISHERS

Editor: RUTH A. PELTASON
Designer: ANA ROGERS

Pages 2–3: BOUGAINVILLEA, PALM BEACH, JANUARY 1994

Library of Congress Cataloging-in-Publication Data

Lauder, Evelyn.
The seasons observed: photographs / by Evelyn Lauder.
p. cm.
ISBN 0–8109–4455–3
1. Seasons—Pictorial works. 2. Nature—Pictorial works.
3. Landscape—Pictorial works. 4. Nature photography.
5. Landscape photography. I. Title
QH46.L38 1994
508'.022'2—dc20 94–8418

Published in 1994 by Harry N. Abrams, Incorporated, New York
A Times Mirror Company

Printed and bound in Italy

Contents

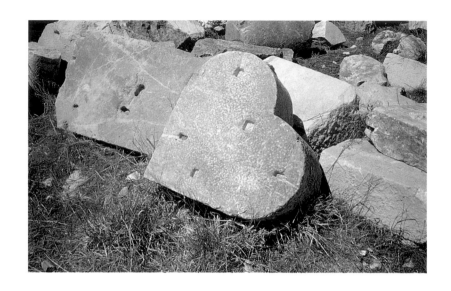

To my father, Ernest Hausner, who first opened my eyes
to the joys of the seasonal changes.

To Leonard for always willingly and patiently stopping the car
whenever we sight a possible shot, and for much, much more.

To my children, who are carrying on the tradition of the love of nature.

Acknowledgments

If it were not for Elizabeth Szancer Kujawski, curator, who kept immaculate track of all negatives, transparencies, and me, none of the photos in this book would ever have been published, or for that matter, hung at the Breast Center of Memorial Sloan-Kettering Cancer Center.

For a variety of reasons which they each know, the following people deserve my everlasting thanks: Holly Solomon, Lance Michael Fung, Susan Hirschhorn, Arthur Klebanoff, Deborah Krulewitch, Linda Manning, Rebecca McGreevy, Rose Paternoster, Margaret Stewart, and Tom Zoufaly.

While the earth remaineth,

seedtime and harvest,

and cold and heat,

and summer and winter,

and day and night shall not cease.

OLD TESTAMENT, GENESIS 8:22

INTRODUCTION

IN 1992, THE WELL-KNOWN NEW YORK ART DEALER HOLLY SOLOMON invited me to exhibit and sell limited editions of about seventy-five photographs at her gallery on Fifth Avenue. To me, the response was stunning. Over 375 images were sold, all for the benefit of charity. The proceeds were donated to the Breast Center of Memorial Sloan-Kettering Cancer Center, where over two hundred landscape photographs are now on permanent display. They hang side by side with the works of fifty-five other photographers, professional and amateur, all of whom donated their work so that patients and their families could enjoy calming views during what might otherwise be an anxious experience.

It is only fitting that I donate all royalties from the sale of this book to the Breast Cancer Research Foundation, which was founded in 1993, and is dedicated to supporting clinical research on this disease.

But it was the comments at the opening night of the exhibition that thrilled me. Friends said, "Evelyn, this is really good." What they hadn't said, but meant, was, 'We came because we like you, or whatever, but this is better than what we expected.'

As an amateur photographer, working in another career in the family's cosmetic business, these kinds of remarks gave much more credibility to my efforts than I had previously supposed. It made me consider my eye more seriously.

Of course, when there was talk about doing a book of my photos, a multitude of thoughts buzzed through my brain.

Isn't it presumptuous to think such a book might even sell?

Was my eye really as open and aware as it ought to be for my pictures to be published? After all, the world is full of photographers far more experienced than I.

But ever since childhood, I'd wanted to do a book of some sort. Why not a book of photos—my passionate hobby?

To have my name on the spine of the book jacket and on the front cover was too irresistible to refuse. When I think of it, these little buzzes actually took only a few seconds to flash through my head. I jumped at the idea like a puppy greeting a familiar figure.

It was agreed that the book should be arranged by season, similar to the exhibition at the gallery. And so it is, with a few surprises thrown in. For example, pictures from South America or South Africa or even Hawaii have seasons reversed from ours. So, a photo of a glacier in Tierra del Fuego, South America, is placed in the spring section of the book.

Also, it is no accident that you'll notice these images are devoid of houses, people, advertising, signs, and other symbols of intrusions into the landscape. There are only two exceptions. In this way, the timeless quality of the scenery is sustained.

To me, the photos in this book are witnesses to the light and the time I actually experienced. They capture a moment that can then be seen again and again. Pictures taken when the light might be just right. The light in these photographs is natural. It is the light from the sun—I've added nothing, nor moved anything. There's been virtually no cropping of these images. They are a personal journal of what I saw at a glance, at that moment with the camera in hand, luckily.

Frequently, it's been disappointing not to have had my camera with me. There have been lost opportunities that could have brought delight in photos. For example, one afternoon while in Budapest, we were walking down a quiet residential street toward a well-known restaurant for lunch. There were no cars and very few people. On the second floor of one of these homes, a window was open that had the white lace curtains that you see only in these Eastern European countries. You know the kind I mean. Leaning on the windowsill was not an elderly woman, which is more usual, but a beautifully groomed black poodle, its paws resting on the edge of the sill, looking for all the world like the guardian of the block, taking in our stroll. It would have made a marvelous shot, but it will be only in our minds now because of these words.

Everyone seems to have definite feelings about which season's photographs are their favorites—to the exclusion of the other three. At least, that was the reaction we noticed at the exhibition. It was the certainty of the preferences that was a surprise to me.

Each season has its own majesty in my eyes—just as Samuel Taylor Coleridge wrote, "Therefore all seasons shall be sweet to thee."

The serenity and calm of a winter snow blanketing the bed of earth has a glorious

beauty while seeming to protect the colorless ground. The naked trees are then seen in contrasting relief against all that whiteness. When all the snow melts, it feeds the seeds in the warming soil, and we start recalling memories about springtime.

When I was a little girl, my father, Ernest Hausner, always took me to Central Park in the springtime to observe the cherry blossom trees and the magnolia trees coming into bloom. (As a matter of fact, I shall never forget the day I brought my firstborn, William, home from the hospital. When I had arrived at the hospital to give birth, the buds on the magnolia trees were tightly shut. On returning home, they opened as if to welcome him, too.) My dad would pick me up to let me smell the lilacs, and he would discreetly pinch a tiny blossom of privet so we could enjoy the fragrance for a few days at home. He made me notice the trees coming into bloom, the bursting open of flowers, the sudden appearance of the sharp, fresh green of the grass, a grass so green, it stings the eyes.

Summer, on the other hand, has a way of creeping up on you. The grass is still green, but not as intensely so. It takes on a more mature color, if you will. We take it for granted while we "ooh" and "aah" over our blooming flowers. Their fragrances, carried by the soft breezes, envelop us. Parenthetically, in two instances, a fragrance experienced this way inspired the addition of floral notes to two perfumes for Estée Lauder, Pittisporum in Knowing and Yellow Broom in Tuscany Per Donna.

Finally, we come to fall. There are never enough words about this season. The abundant variety of fall's colors are Mother Nature's finale in a performance of such glory that she is then forced to recuperate until the cycle again renews itself a few months later.

Who can choose their favorites among these seasons? I certainly can't. They are like our love for our children. There's always room for the next one.

Just like the ephemeral quality of music that gives fleeting pleasure, look at these photos for your own reasons, perhaps to see in them the beauty of the moment as it was. The visual horizons they offer, and perhaps the horizons of spirituality, are in the experience of what was observed.

EVELYN H. LAUDER
NEW YORK, 1994

WINTER

IMAGINE A CROSS-COUNTRY SKIER WITH A CAMERA dangling over her chest, stopping, planting the poles into the snow, removing mittens, grabbing the camera—click, click—turning off the camera, putting on the mittens, grabbing the poles, and then trying desperately to catch up with everyone on the trail. That's how most of the snow photos were shot.

Then there was an incredible double rainbow outside the hotel room window when we were in Hawaii. What an experience to see and grab with a camera.

One Christmastime, we were in the Caribbean aboard a sailboat, when a sunset suddenly formed marvelous colors for us. It was a lovely holiday gift.

Most of all, when winter snow covers the stones and the ground, causing softening, sensuous forms to emerge, there's no need to say anything more.

Opposite: VERY SPECIAL DELIVERY, COLORADO, 1983
*This little fellow was using the cross-country
ski trail as a delivery route and was so charming.*

A lovely lady, garmented in light
From her own beauty.

PERCY BYSSHE SHELLEY,
"THE WITCH OF ATLAS"

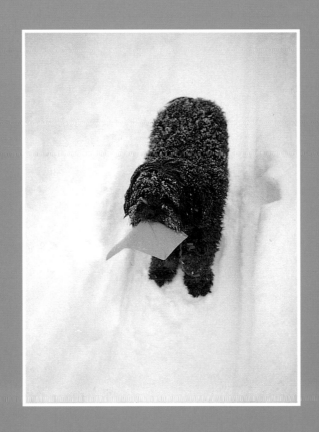

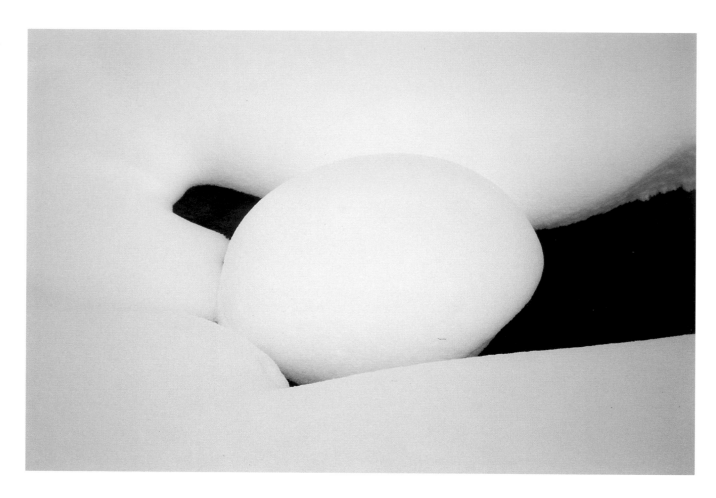

SNOWBALL, COLORADO, 1980

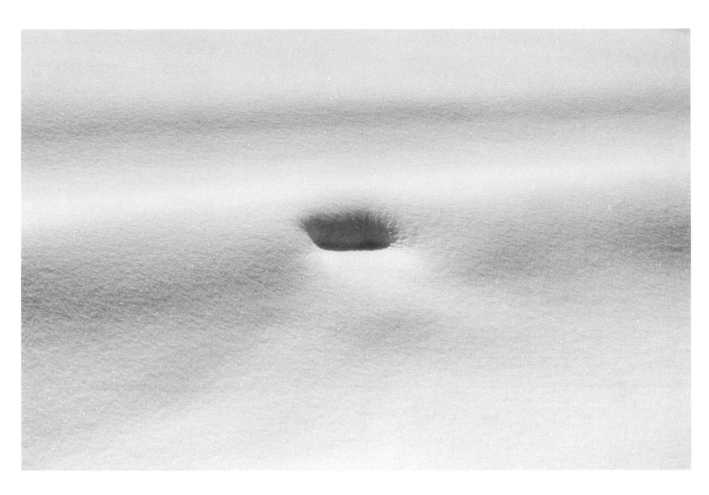

SNOW NAVEL, COLORADO, 1992

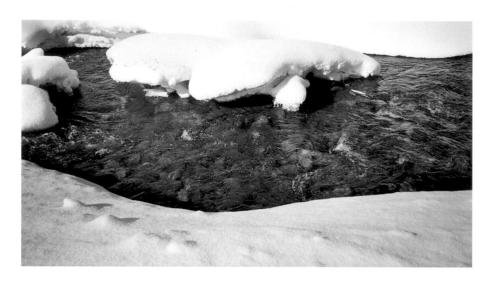

ROARING FORK RIVER, COLORADO, 1991
This narrow but long river feeds into the Colorado River after flowing through the town of Aspen. The stones at the bottom have brilliant colors.

Right: JUST AFTER A FRESH SNOW, COLORADO, 1980

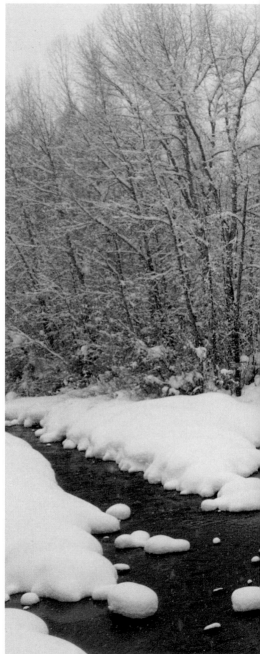

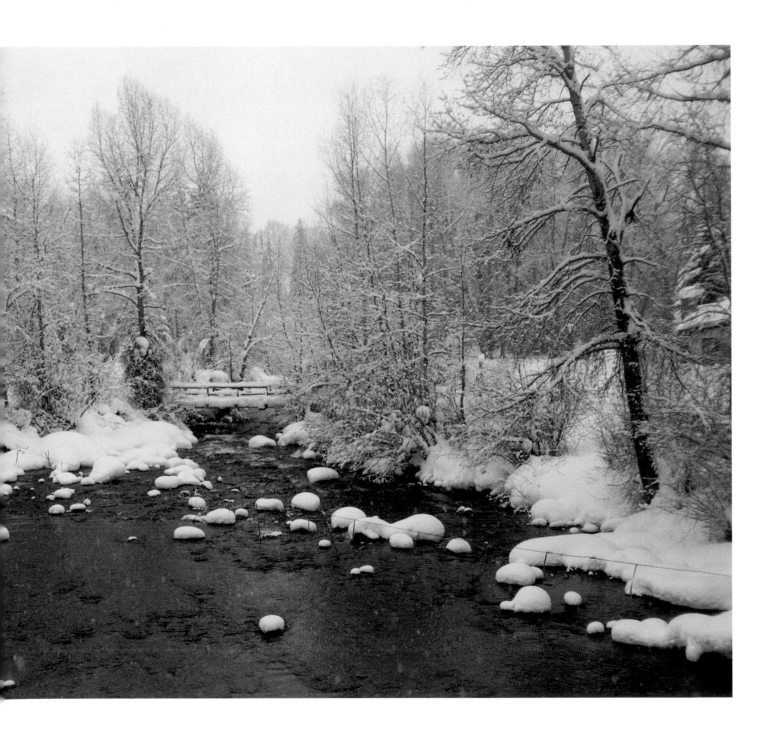

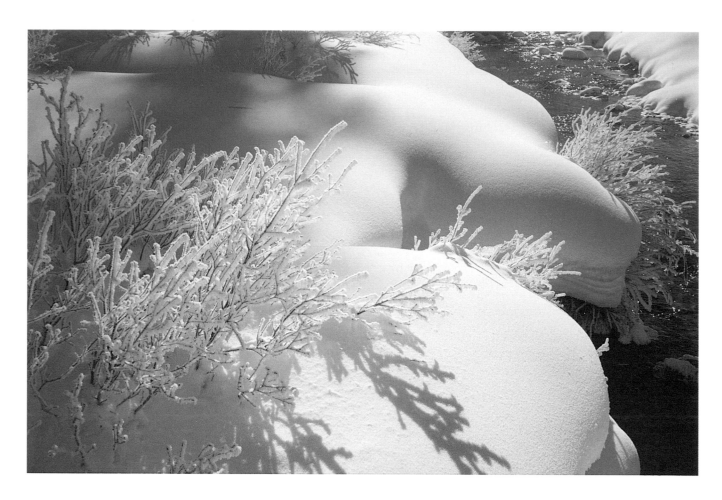

WINTER, COLORADO
*Notice the hoarfrost on the bushes and the sensuousness of the forms. I ski here
all the time, and have never ever seen the light quite like that since that day.*

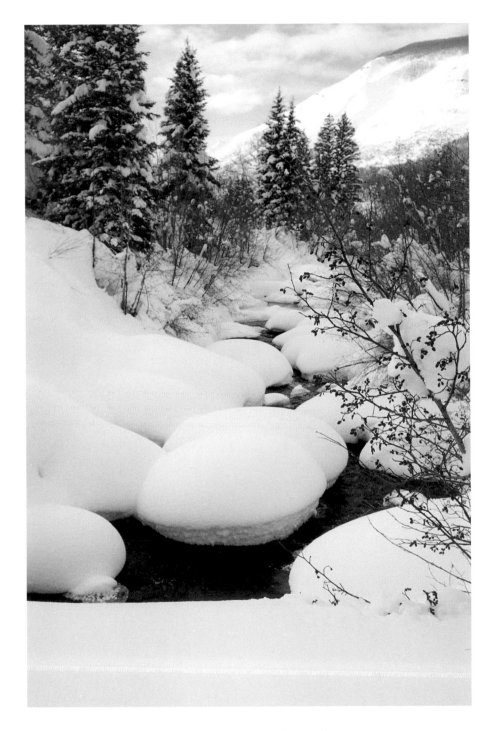

Just After a Snowfall III, Hunter Creek, Colorado, 1980

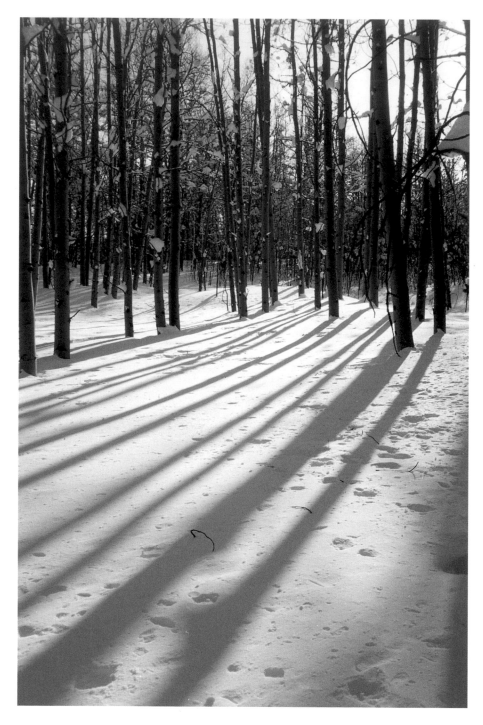

SUN IS SETTING, INDEPENDENCE PASS, COLORADO, 1986
The snow drops off the upper branches, pockmarking the snowy surface below, almost like a blessing.

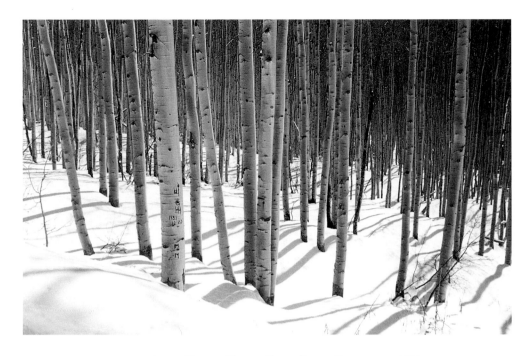

ASPEN GROVE, CASTLE CREEK ROAD, COLORADO, 1991

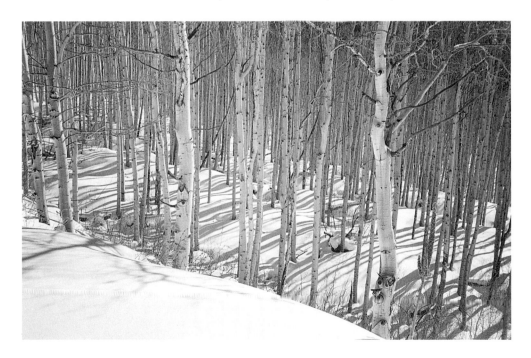

ASPENS ON ROADSIDE—WINTER II, ASPEN, COLORADO, 1987

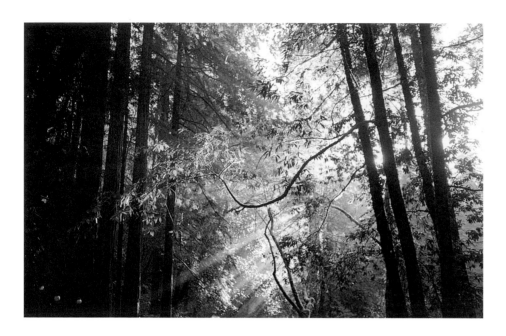

BOHEMIAN GROVE—SUNLIGHT, CALIFORNIA

This is unusual, because women normally do not have privileges to visit "The Grove," as it is called.
The damp air made it possible to capture the sun's rays from a moving bus as we arrived.

Right: BOHEMIAN GROVE—FERNS, CALIFORNIA, DECEMBER 1988

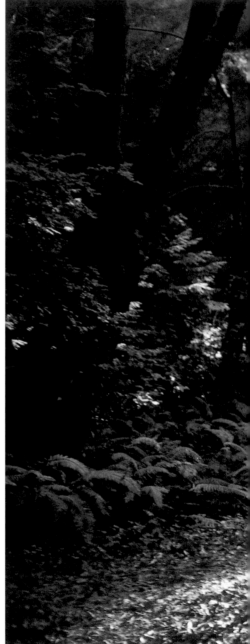

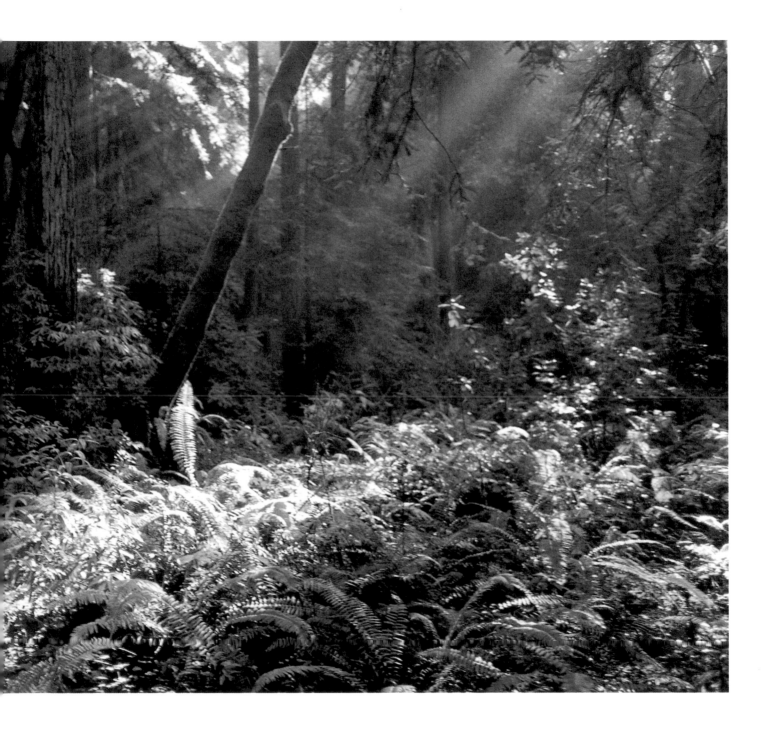

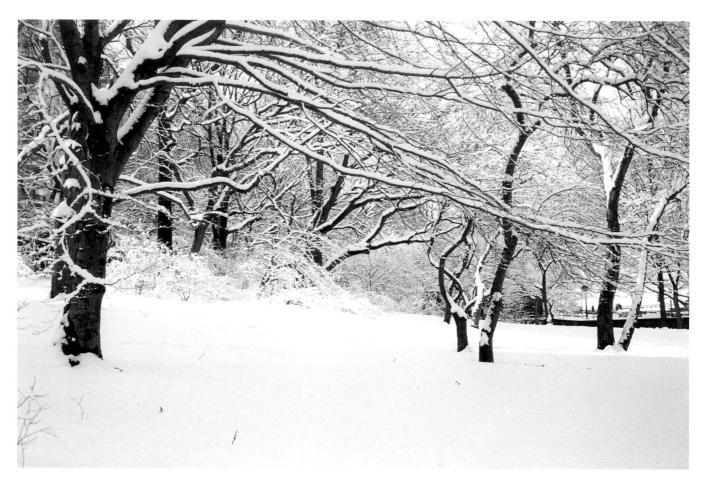

CENTRAL PARK NEAR 72ND STREET AND FIFTH AVENUE, NEW YORK, 1992

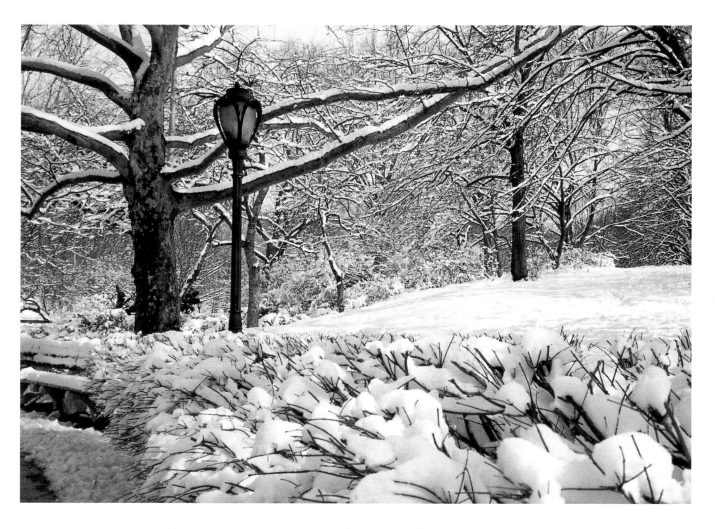

MORNING AFTER THE MARCH 1992 SNOWSTORM, CENTRAL PARK, NEW YORK
When there's a lot of moisture in the air, the snow clings to everything beautifully.
But by midday, the tree limbs are bare again.

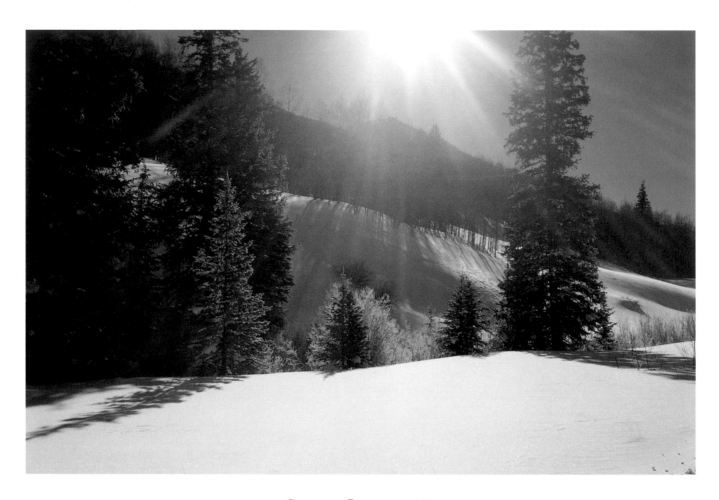

Blessings, Colorado, 1988

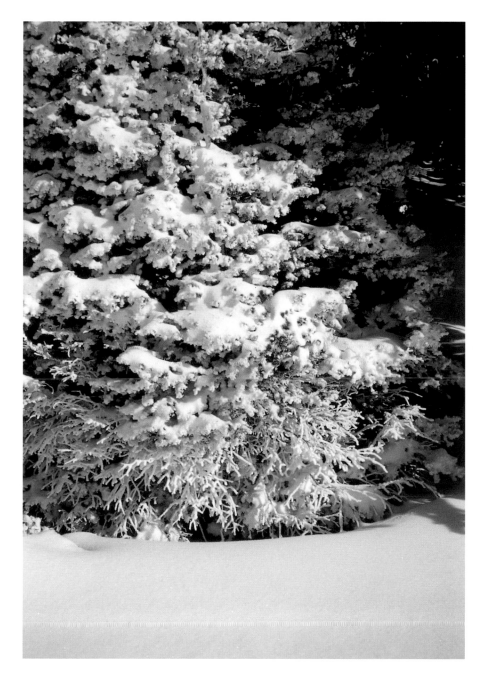

Colorado Spruce, Aspen, February 1988

SPRING

SPRINGTIME IS A TIME OF FLIGHT, NOT ONLY FOR migrating birds but also for our family. The photos in this group are from all over the world.

Some of them were taken from aboard a cruise ship, *Terra Australis*, in the Tierra del Fuego area of southern Chile.

Leonard and I had always dreamed of taking a long trip to Italy, and after years of procrastination, we actually took a three-week journey in the springtime, specifically, May of 1992. In this group are just a few photos of the view from the San Pietro Hotel, looking toward the town of Positano.

Others were taken closer to home, capturing the peak performance of trees in Central Park. Right in our backyard in the country, the irises were blooming by the edge of the pond. Tadpoles were swarming at the nearby shore, and the heat of sunlight finally began to burn through our shirts. With a sigh, we could look forward to a weekend sitting on a porch swing, enjoying the colors and the warmth of this lovely season.

Opposite: WISTERIA IN CENTRAL PARK I, NEW YORK, MAY 1993

If we had no winter,
the spring would not be so pleasant.

ANNE BRADSTREET,
"MEDITATIONS DIVINE AND MORAL"

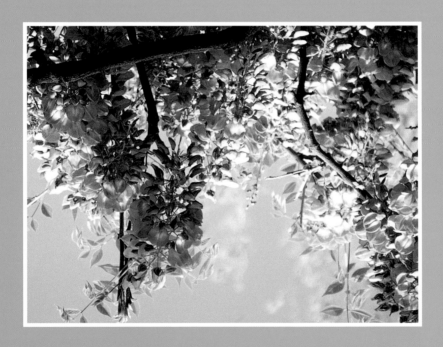

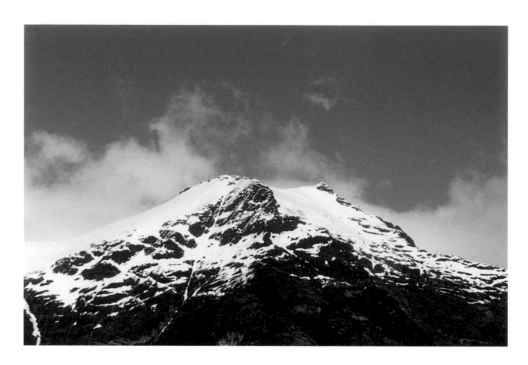

TIERRA DEL FUEGO II, SOUTH AMERICA, OCTOBER 1993

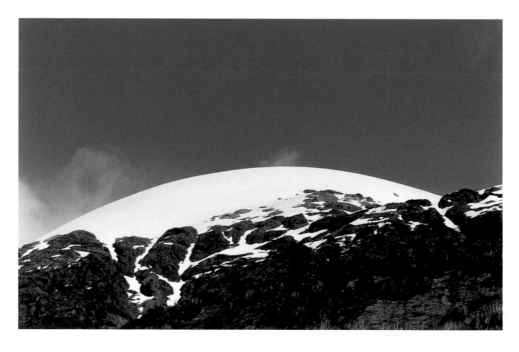

TIERRA DEL FUEGO I, SOUTH AMERICA, OCTOBER 1993
The snow had formed into a perfect semicircle.

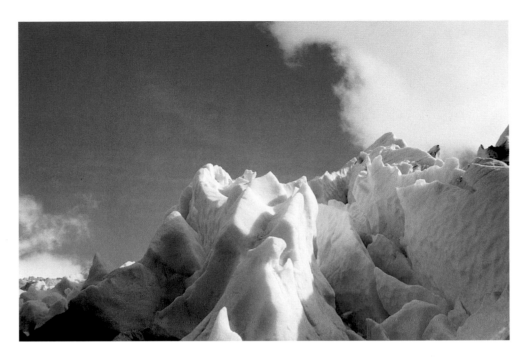

GLACIER IN TIERRA DEL FUEGO II, SOUTH AMERICA, SPRING, OCTOBER 1993

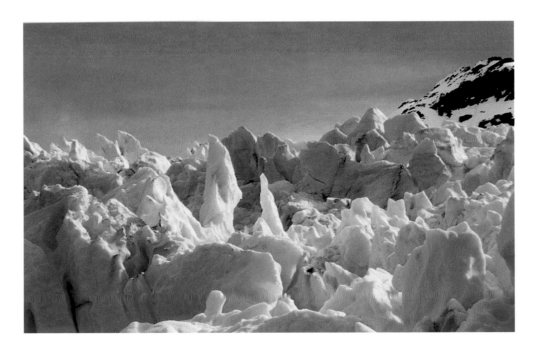

GLACIER IN TIERRA DEL FUEGO, SOUTH AMERICA, SPRING, OCTOBER 1993
*We actually hiked to the base of this glacier. There was a stream at the bottom into which huge blocks of ice
"calved" with the accompanying sounds of release—cracking noises that thundered and echoed in our ears.*

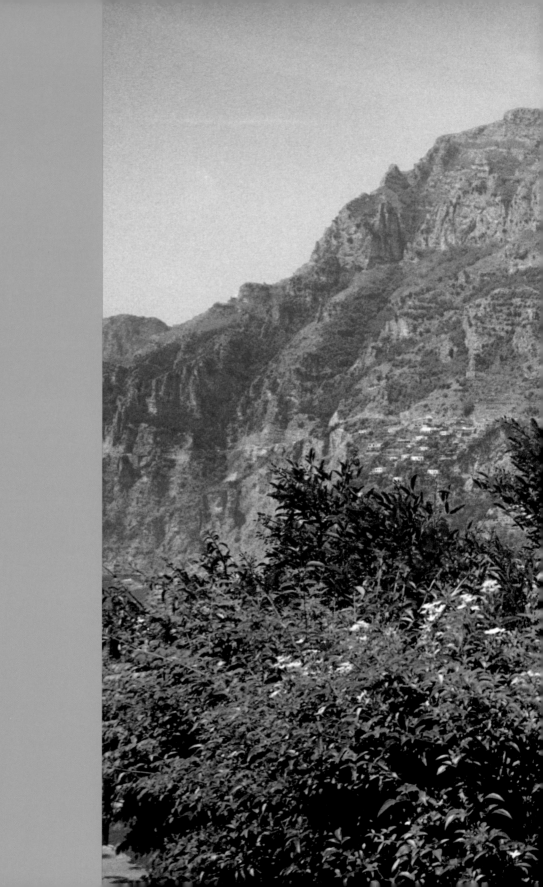

POSITANO III, ITALY, 1992

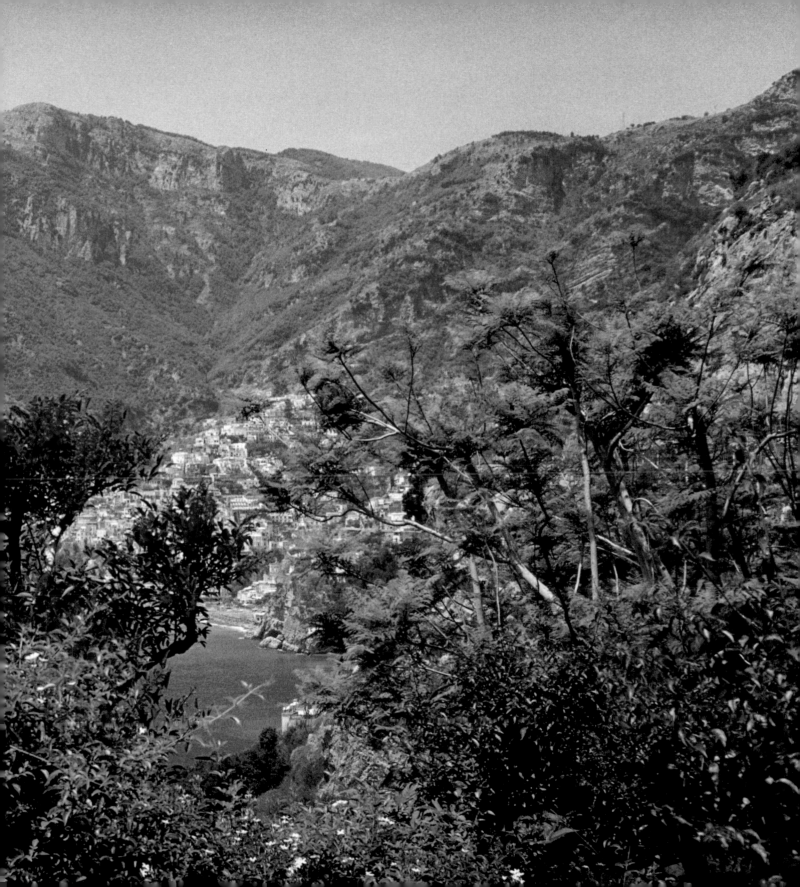

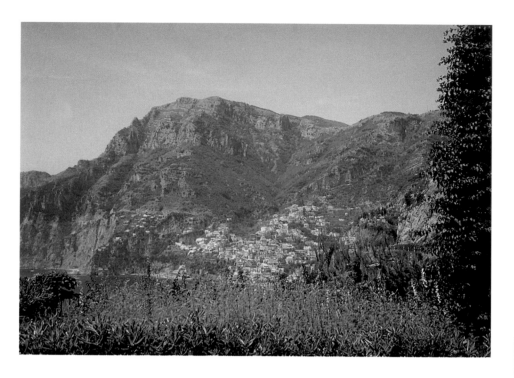

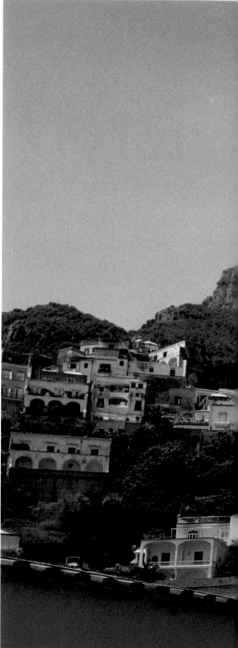

Positano I, Italy, 1992

Right: Positano II, Italy, 1992

Overleaf: Spring Lake, New York State, 1989
The sky is reflected in the pond, in which hundreds of tadpoles are gathered at left.

Overleaf inset: Red Canoe, New York State, 1989

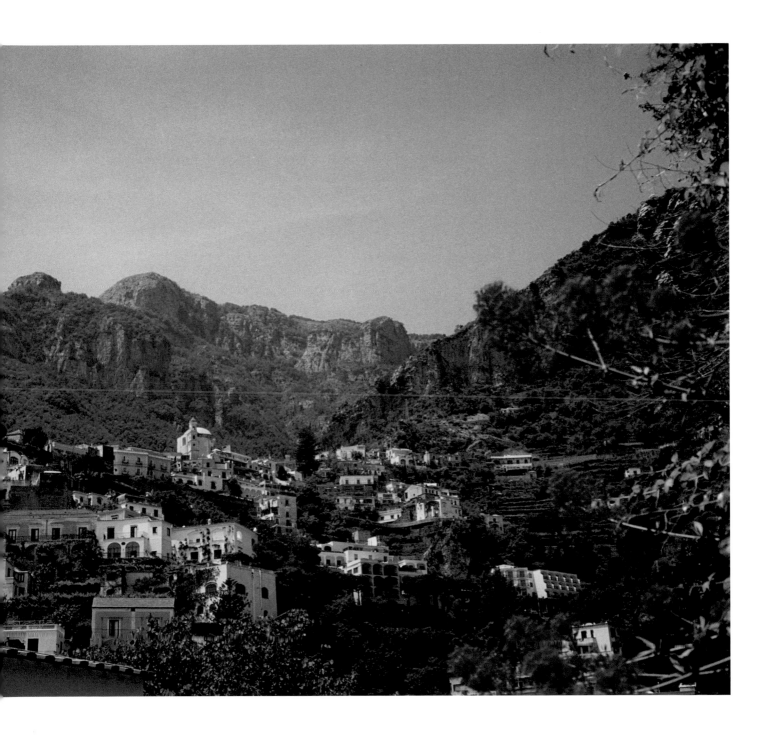

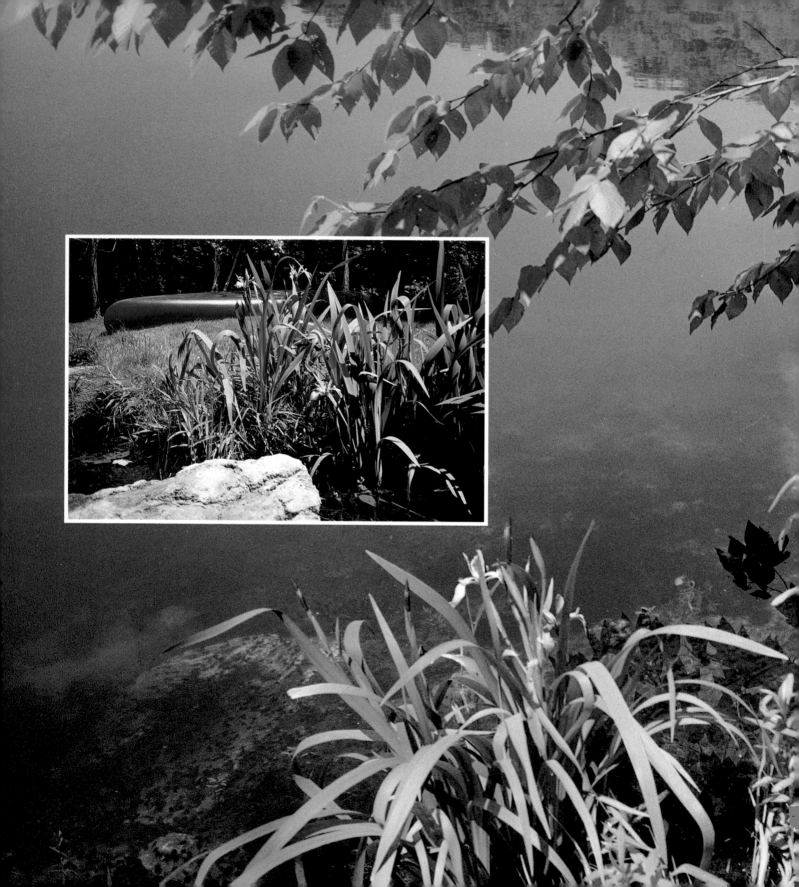

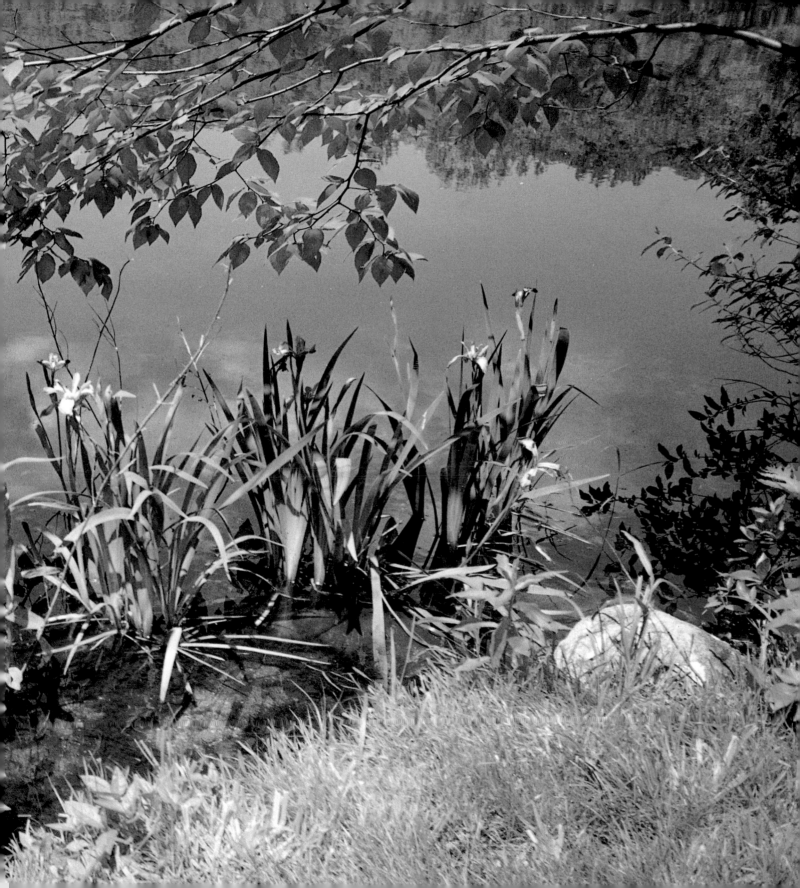

EXHAUSTED AND TWISTED TREE, TIERRA DEL FUEGO,
SOUTH AMERICA, SPRING, OCTOBER 1993
The ground was called a bog, a surface on which I'd never previously walked.
It had a resilient and spongy feeling. When we scraped off the top, we discovered
we actually were walking over water, supported by this thin layer.

VIEW FROM THE PICNIC REST DURING HIKE, DORDOGNE, FRANCE, 1986

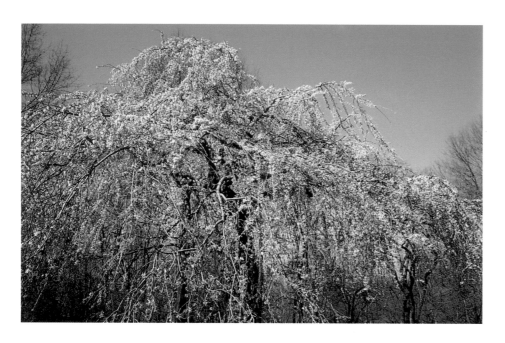

WEEPING CHERRY TREE, CENTRAL PARK, NEW YORK, 1990

Right: MAGNOLIA TREES (WHITE AND PINK),
CENTRAL PARK AND 70TH STREET, NEW YORK, 1990

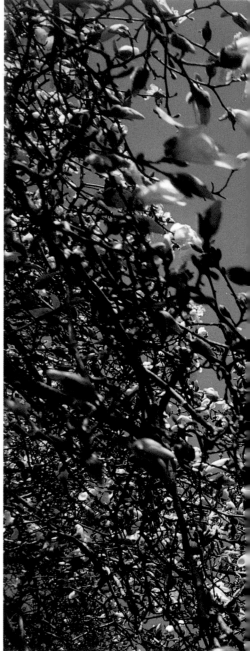

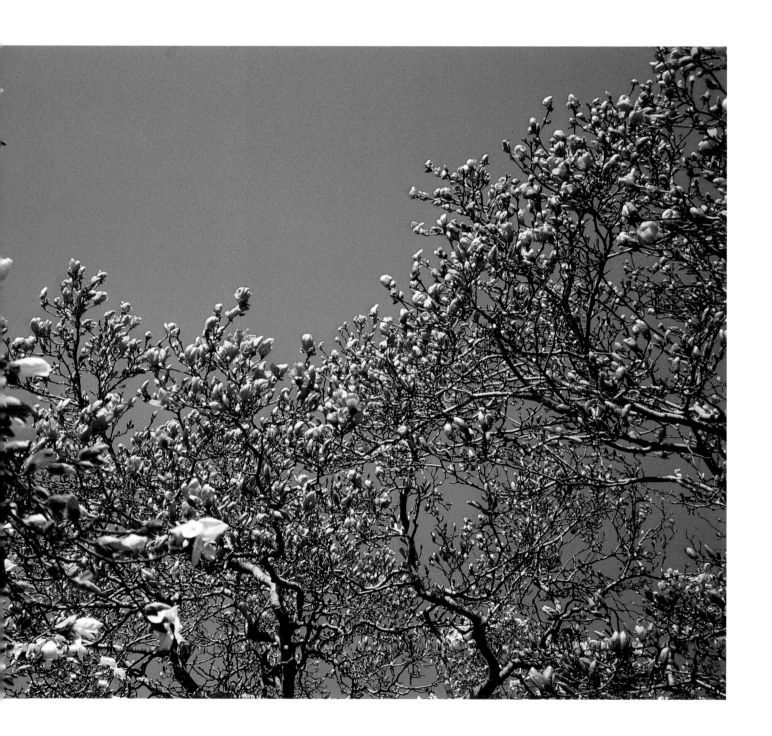

IN THE GARDEN AT THE GRAND OLD
OPRYLAND HOTEL II, NASHVILLE,
EARLY JUNE 1993

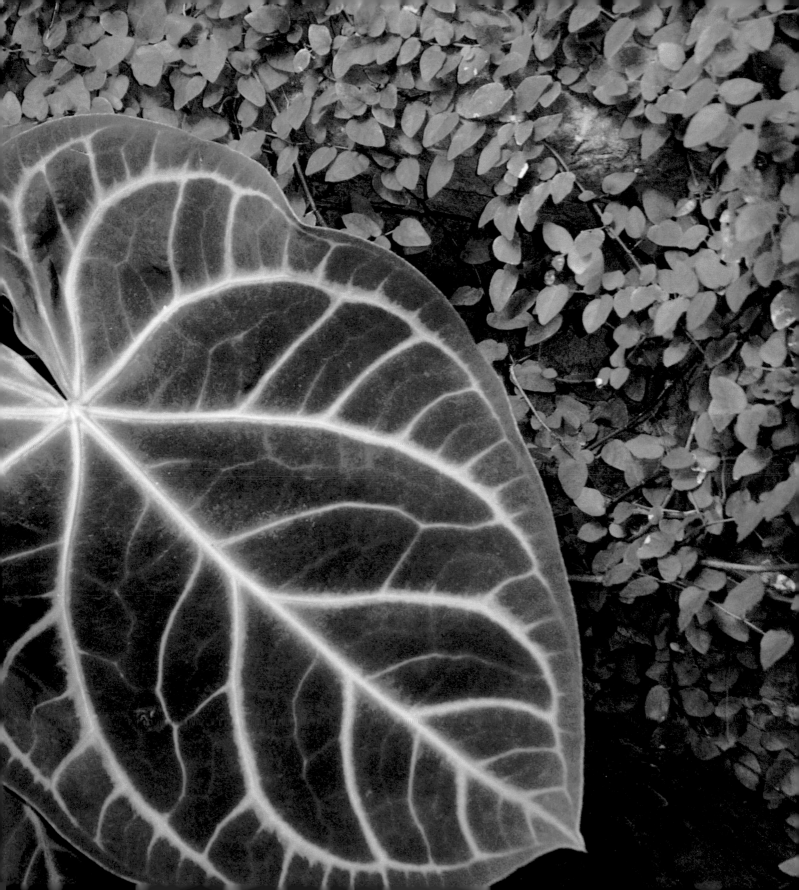

Summer

Summer is also the season for travel, and these photos probably reflect the widest variety of countries in the world—from the United States to Bali, to Indonesia, Turkey, and South Africa.

In summer, the flowers are most abundant, the best of them from my very own garden. Against a dark blue sky and that glorious green grass, the flowers and shrubs are dramatic. The languid days that are filled with hikes or swimming, and reading or listening to concerts, blend from one to the other. The light of summer lasts so long, making it a season that no one wants to have end. But eventually, far too soon, it does.

Opposite: Apricot Poppies, Colorado, 1990

*Summer afternoon — summer afternoon;
to me those have always been the two most
beautiful words in the English language.*
Henry James,
quoted by Edith Wharton, *A Backward Glance*

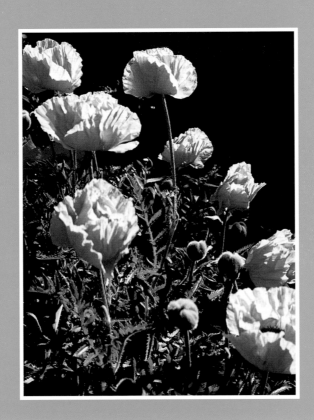

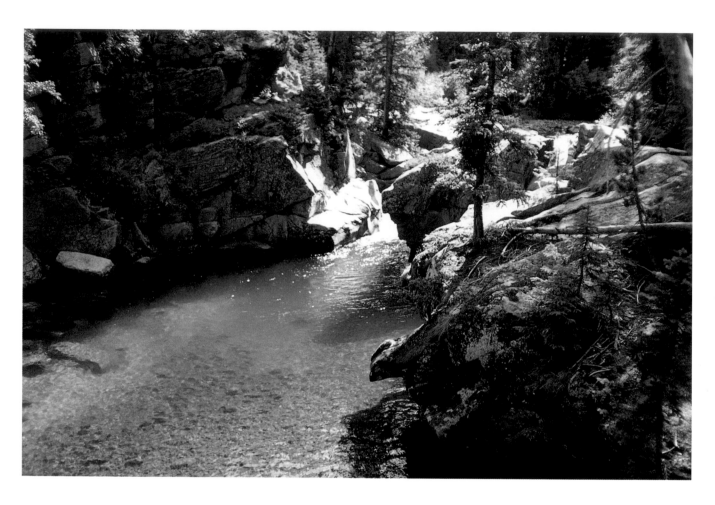

POOL NEAR THE GROTTOS, COLORADO, 1990

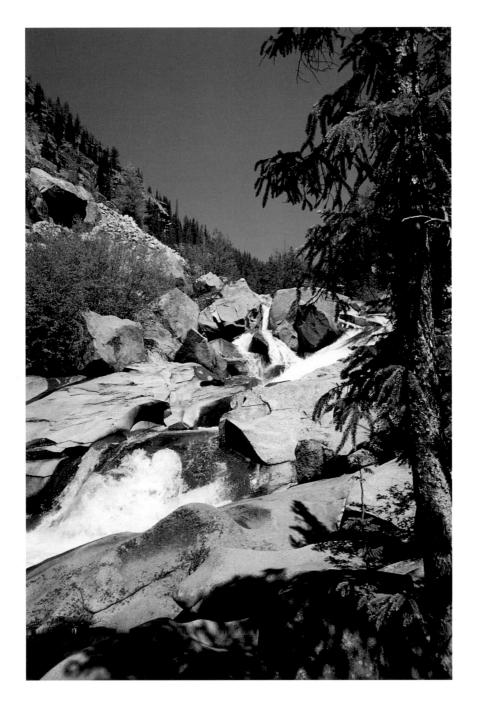

The Grottos, Colorado, 1991

ASPEN CATHEDRAL,
COLORADO, 1991

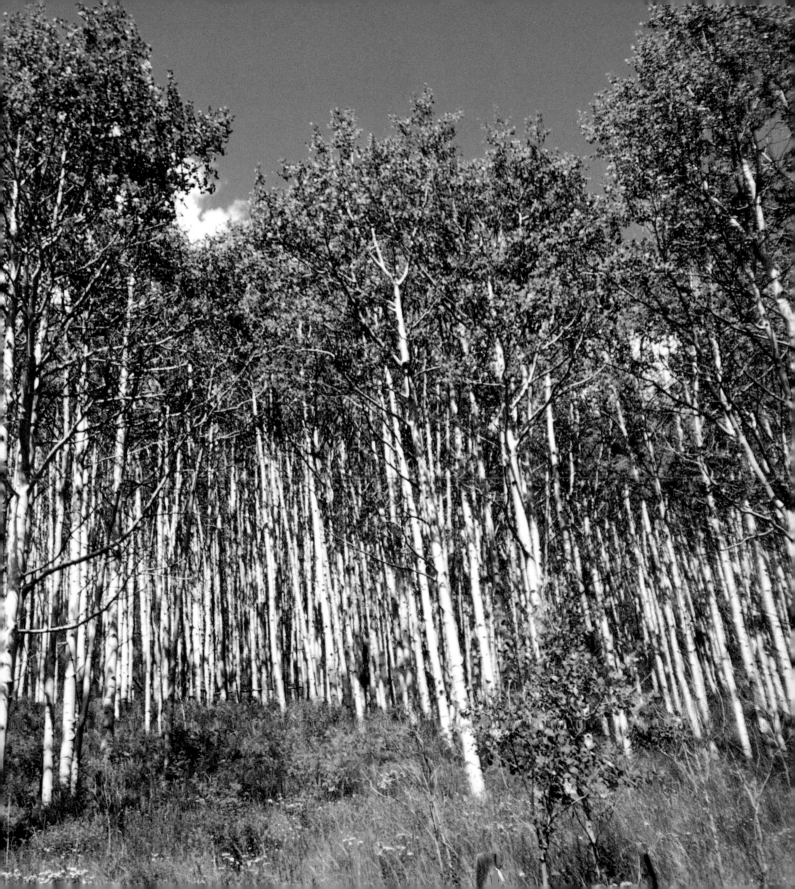

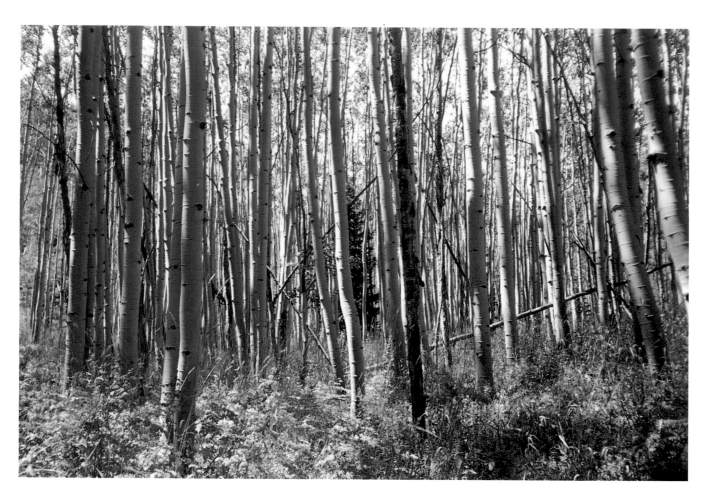

ASPENS, ASHCROFT, COLORADO, 1986

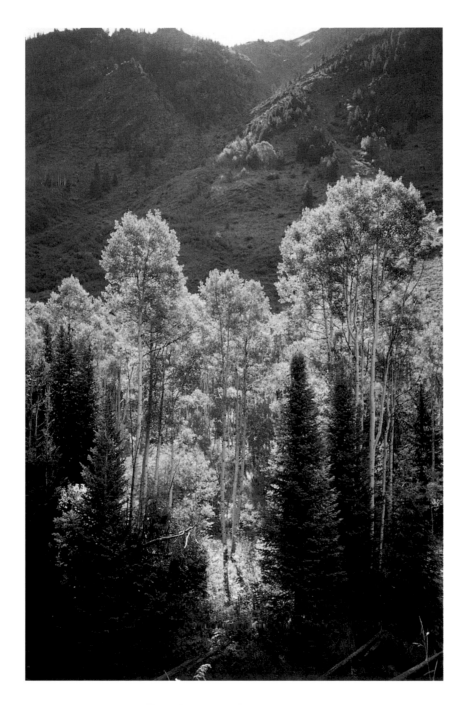

Early Morning, Colorado, 1991

FIREWEED, COLORADO, 1989

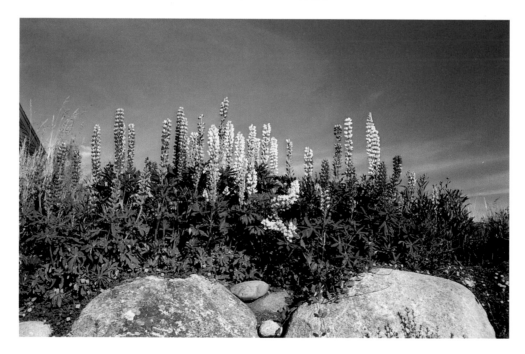

LUPINES, COLORADO, 1982

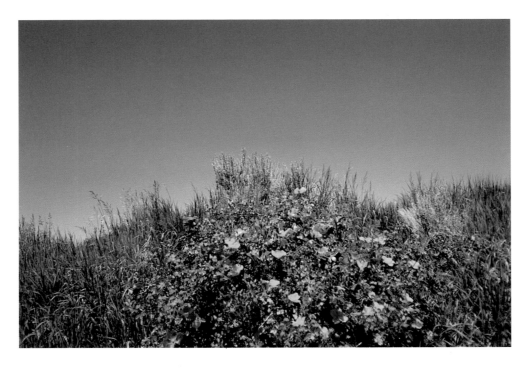

AUSTRIAN COPPER ROSES AND SKY, COLORADO, 1990

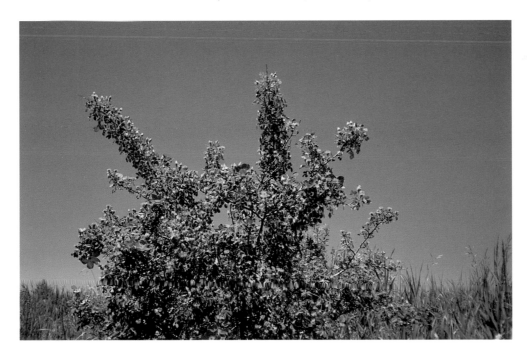

AUSTRIAN COPPER ROSES, COLORADO, 1990

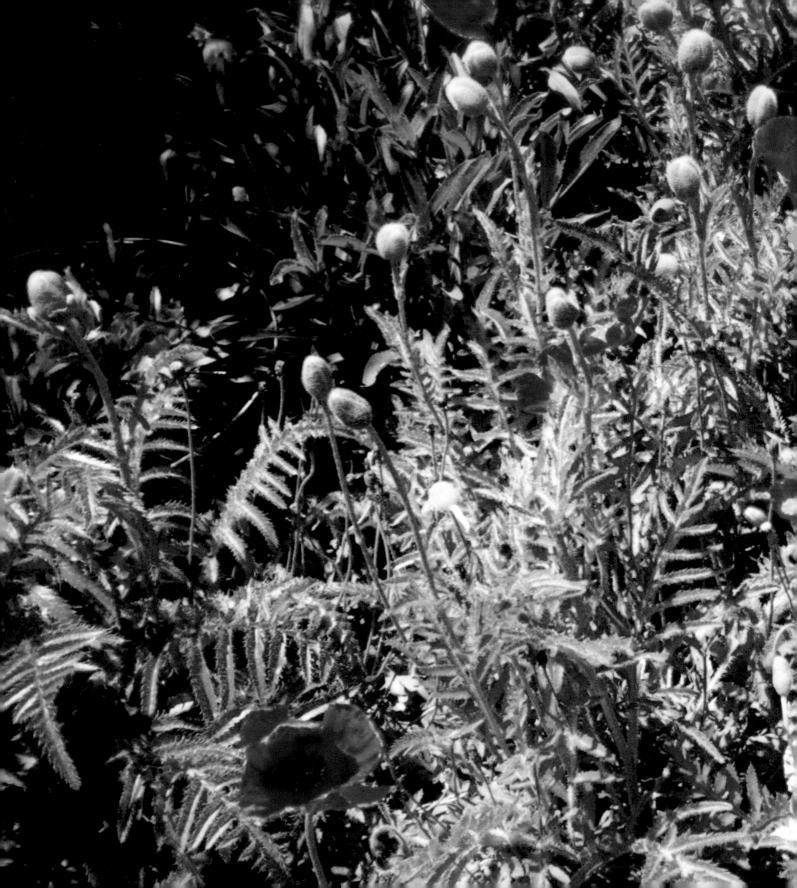

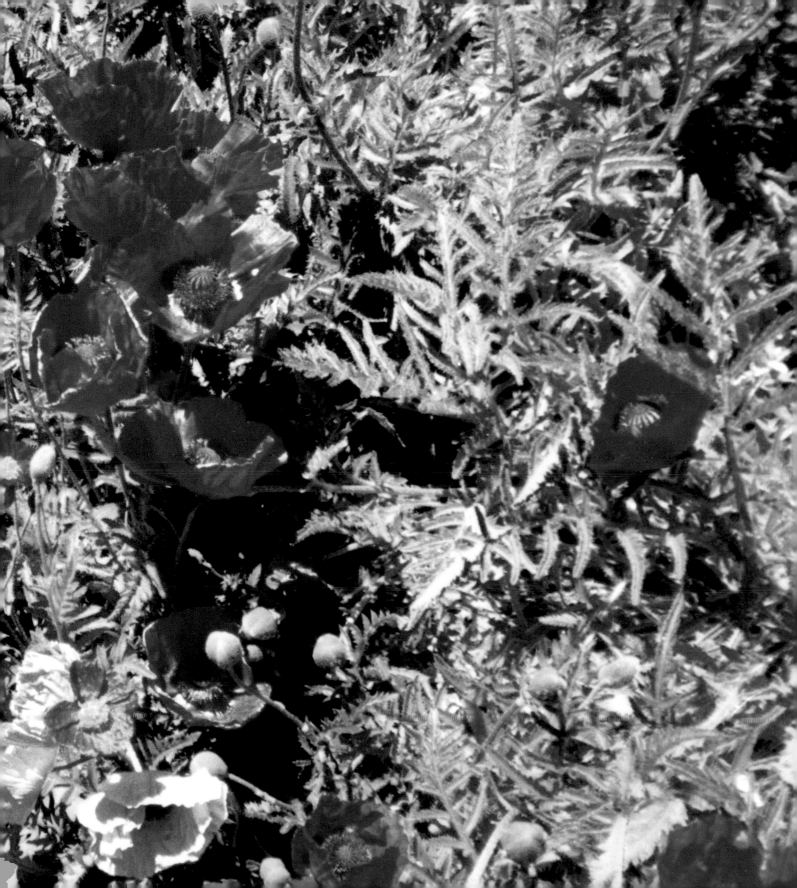

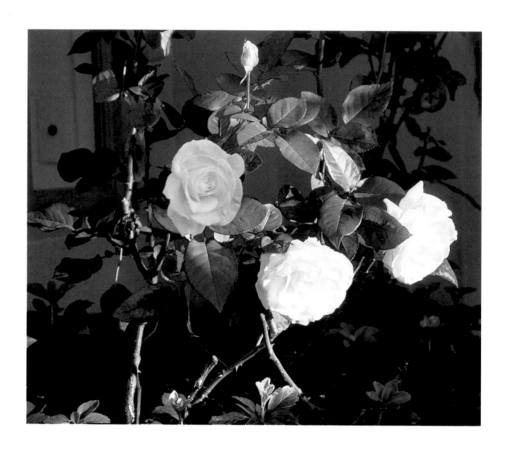

Previous pages: MORE POPPIES, COLORADO, 1990

Above: GOOD MORNING, NEW YORK, 1992

Right: ROSES OUTSIDE MY WINDOW, NEW YORK, 1990

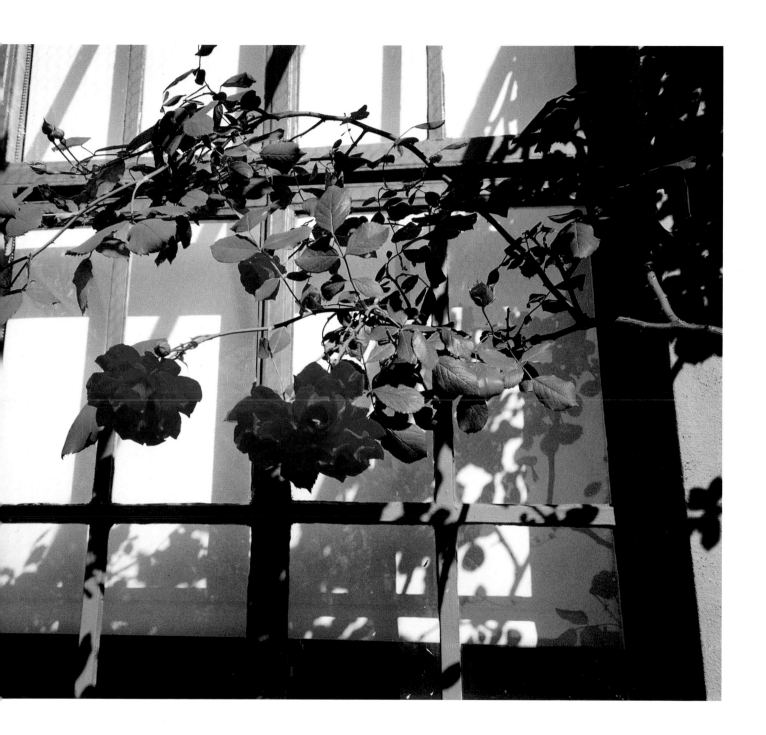

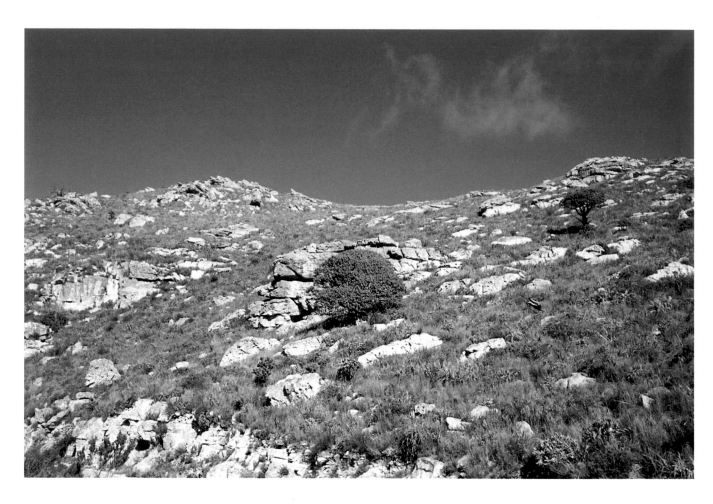

TABLE MOUNTAIN, CAPETOWN, SOUTH AFRICA, FEBRUARY 1990

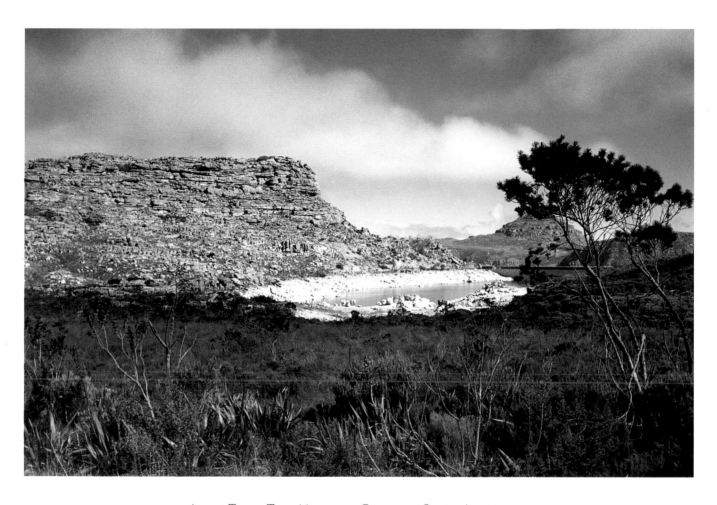

AT THE TOP OF TABLE MOUNTAIN, CAPETOWN, SOUTH AFRICA, 1990

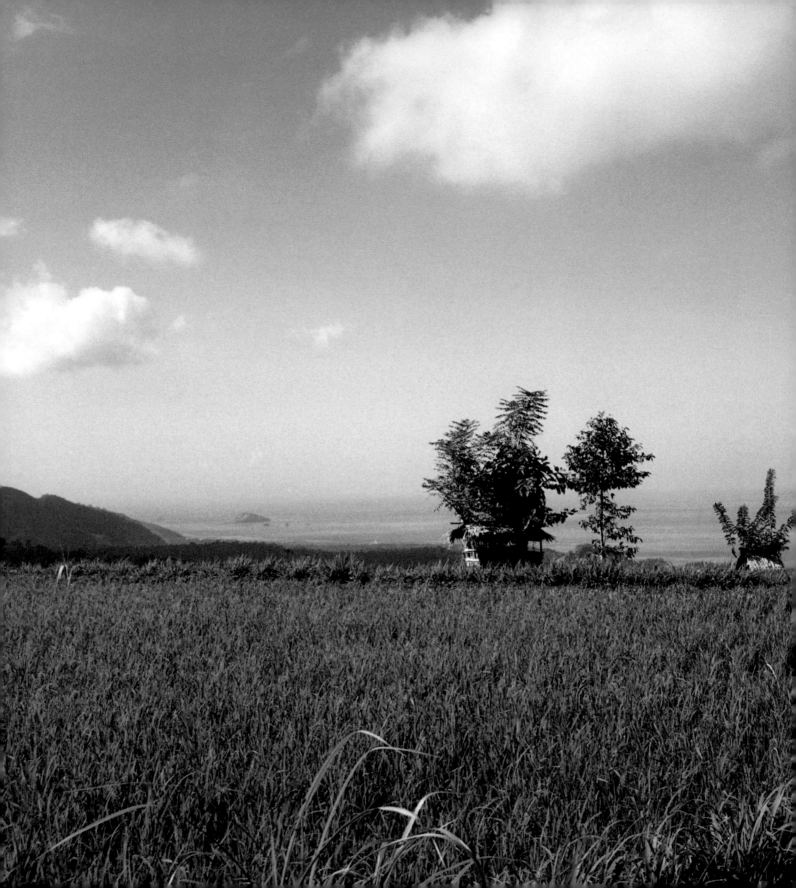

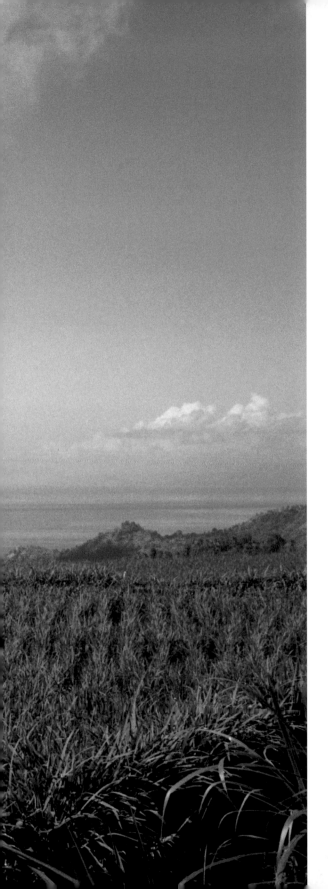

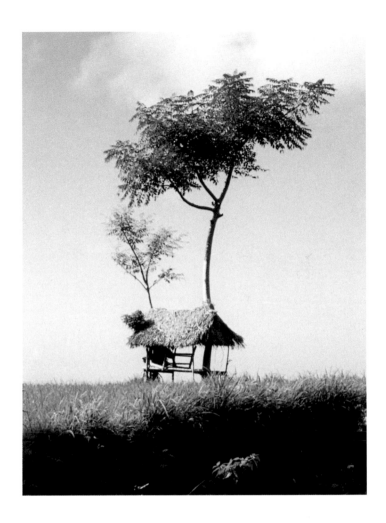

Left: REST HOUSES IN RICE FIELDS, BALI, SUMMER, 1993
*These tree houses are used by the workers in the surrounding rice fields
to lunch in and to get out of the searingly hot sun.*

Above: REST HOUSES IN RICE FIELDS II, BALI, SUMMER, 1993

Overleaf: RICE FIELDS IN BALI, SUMMER, 1993

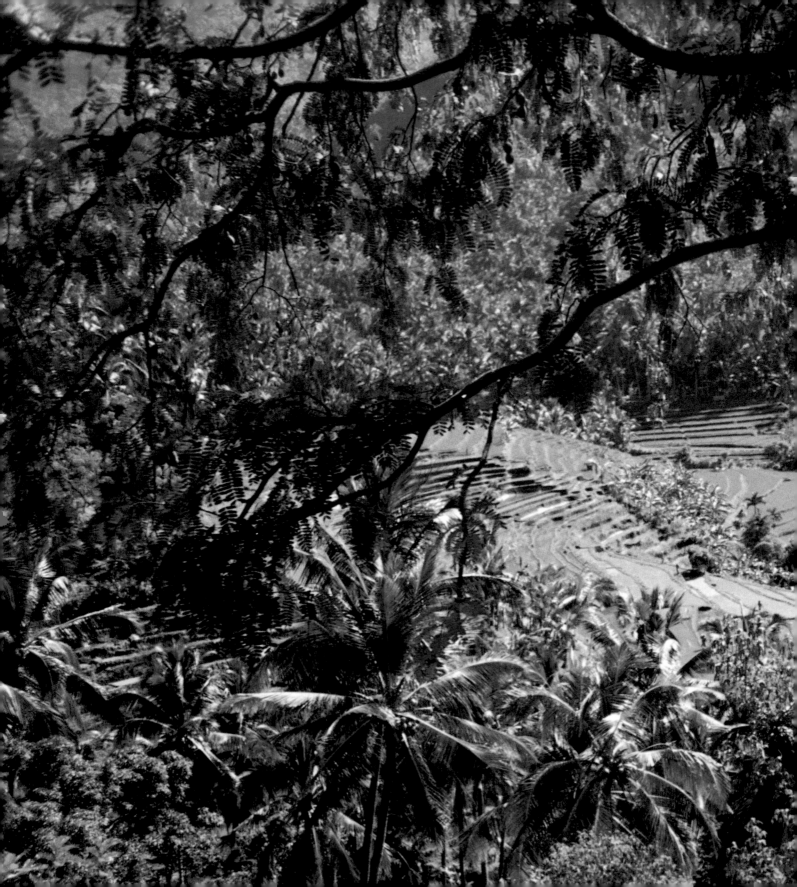

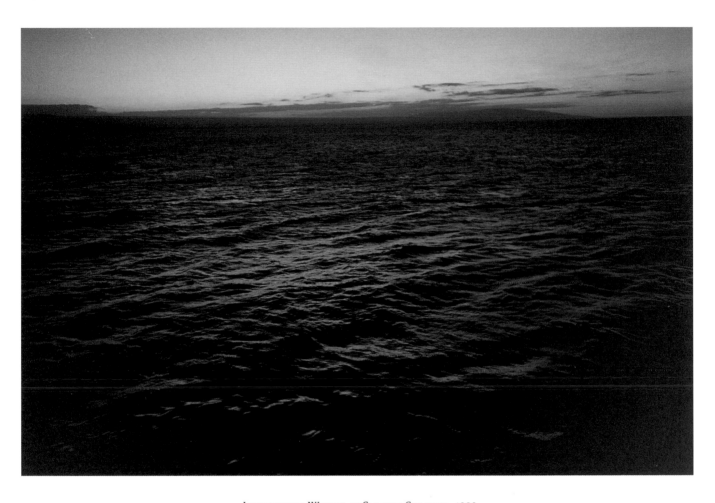

INDONESIAN WATERS AT SUNSET, SUMMER, 1993
On our first day out of port, we were followed by a whale at sunset, who visited with us for over an hour.
A few days later, also at sunset, a school of dolphins kept up with us for over a mile.

Overleaf: FERN AND PINE, NEW YORK STATE, 1990

Overleaf inset: FAHNESTOCK FERNS II, NEW YORK STATE, 1989

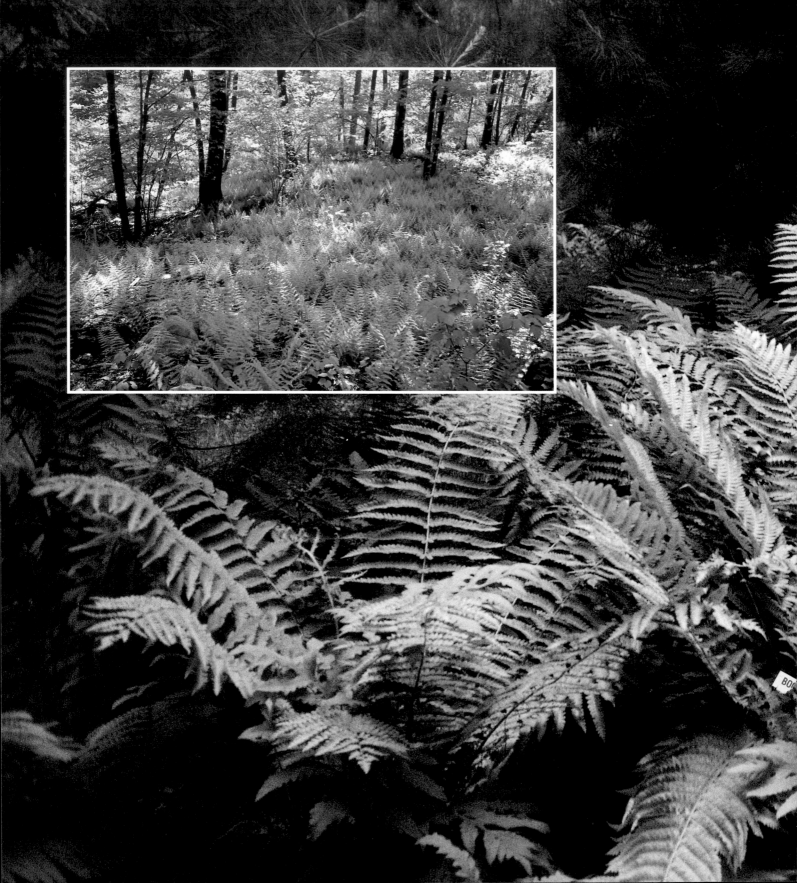

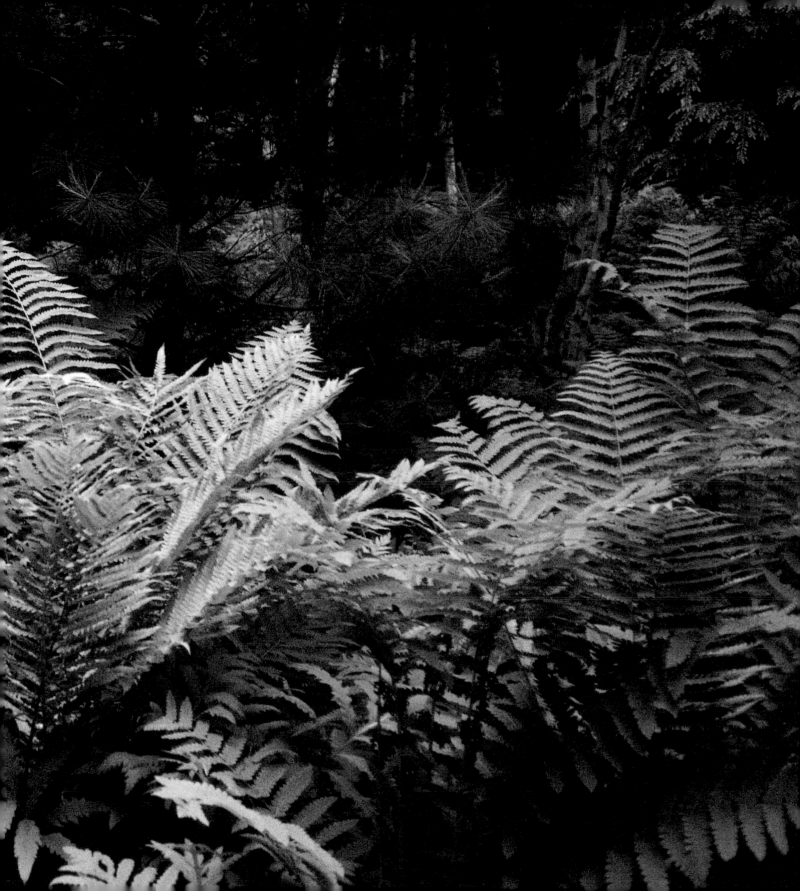

FALL

NOTHING CAN QUITE COMPARE TO AUTUMNAL displays of color. The final glorious weeks of foliage before the winter sets in can be more breathtaking than any other season.

In this section, you'll see colorful leaves having left their branches, up close on the grass or making a floor for other things.

You'll notice dramatic skies in the Midwest and even in New York City. Most of us never look up at that sky. Normally, if we try to, tall buildings block our view. But in fact, our skies are glorious. We have to look harder and higher.

There are photos of Saranac Lake in the Adirondack Mountains of New York State, the American West, and Tuscan roads near San Gimignano in Italy.

Walking on fallen leaves, footsteps are magnified, and the pungent, winey fragrance can make your head almost spin. Days can still have a lingering warmth to remind us of summer, but ultimately, fall pulls us reluctantly away toward the winter.

Opposite: CRABAPPLE BRANCH, NEW YORK, AUTUMN, 1992

Days decrease and autumn grows,
autumn in everything.
ROBERT BROWNING, "ANDREA DEL SARTO"

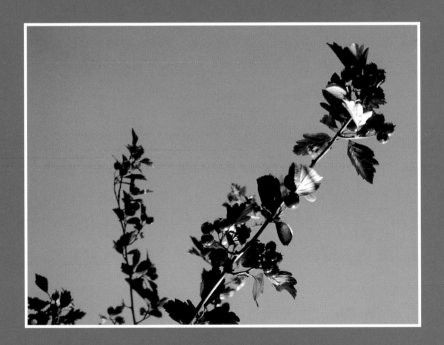

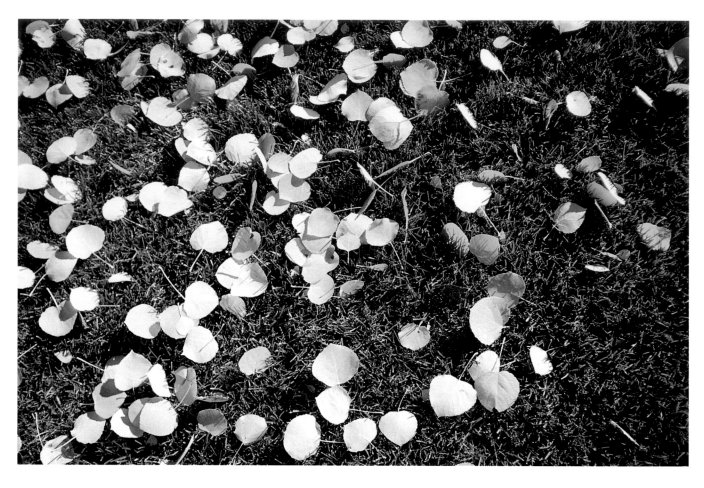

ASPEN LEAVES IN AUTUMN, COLORADO, 1988
En route back to New York from Australia, I stopped in Colorado to transplant an aspen tree.
The grass was so green, the leaves so gold, like coins. The contrast in the sunlight was stunning.

Opposite: ASPENS IN AUTUMN, COLORADO, 1988
This was the tree that required moving. Five years later, it's still thriving.

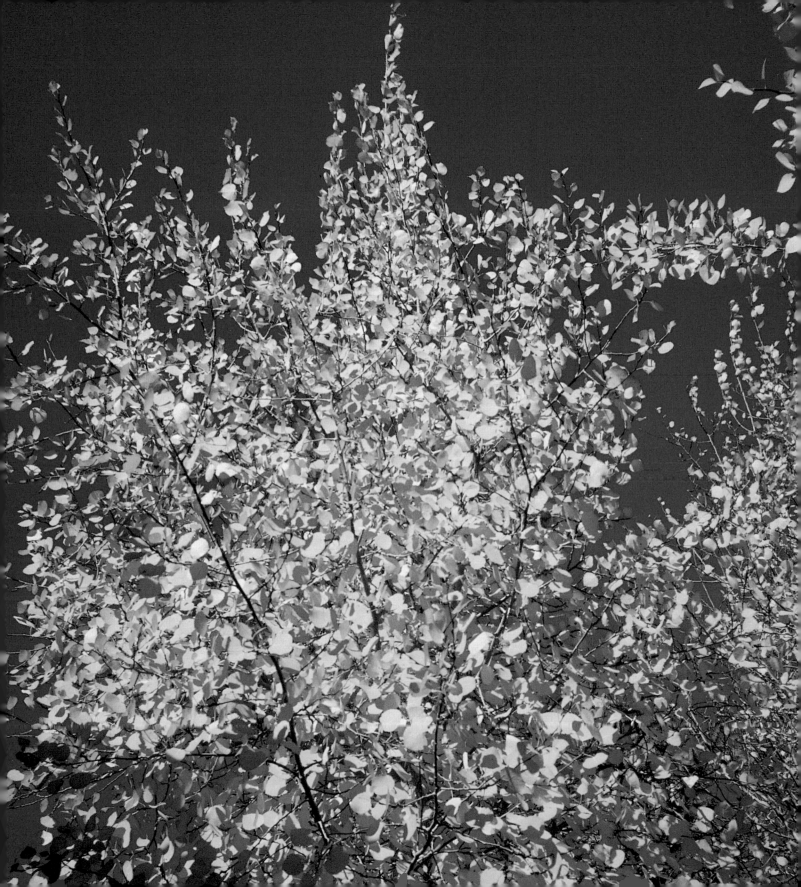

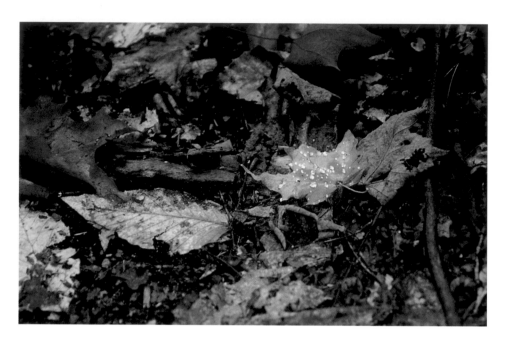

MORNING DEW, UPSTATE NEW YORK, 1992

The heads of dew sparkled on the autumn path, and I was eager to try out the camera. It worked.

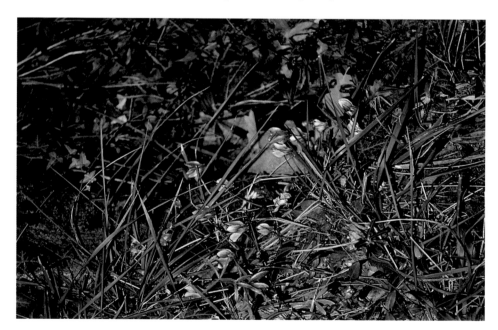

WILD CYCLAMEN, ITALY, 1992

*One day, my husband and I went to the Gori Foundation, near Florence, to see the magnificent private
outdoor sculpture garden. These little cyclamen were hiding under the trees on a shady hillside. Believe it or not,
shortly after taking this photo, a bullet whistled past our ears from a hunter's rifle and landed behind us.*

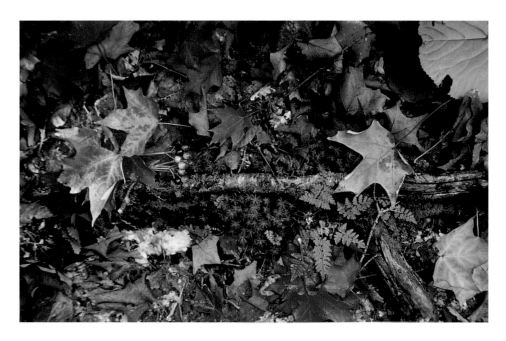

AUTUMN IN SARANAC I, 1992
We took a hike at Saranac Lake with friends, and every step brought us these kinds of colors at which to marvel.

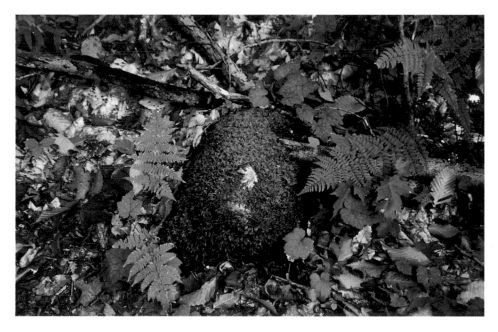

AUTUMN IN SARANAC II, 1992
Same hike, same time of day.

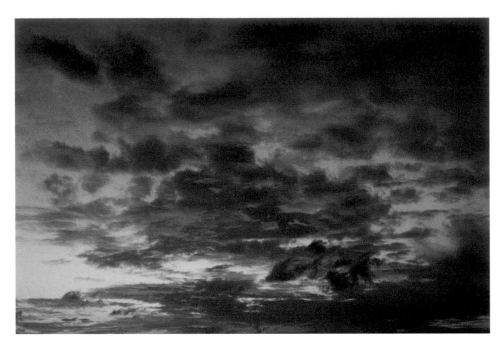

CARIBBEAN SUNSET, CHRISTMAS, 1990
We had just anchored within sight of Antigua and were about to have dinner when we noticed this beautiful sunset.

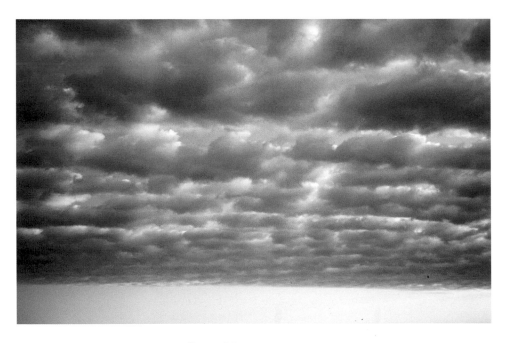

DAWN, MINNEAPOLIS, 1993
In the fall, Leonard and I went to Minneapolis for a weekend,
and one morning as we awoke and opened the curtains, this is what we saw.

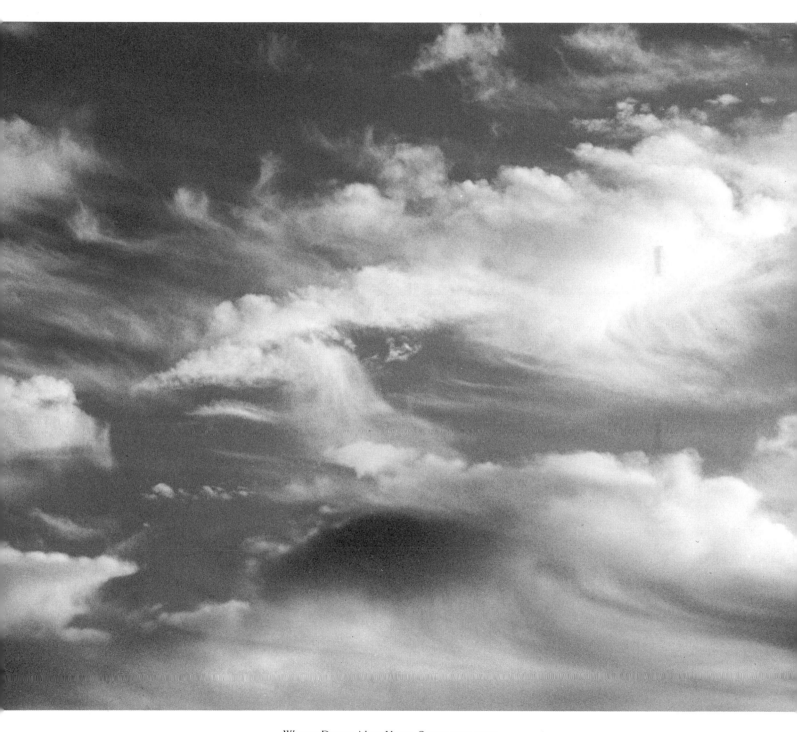

WINDY DAWN, NEW YORK, SEPTEMBER 1993
The sky over New York City can be just as beautiful as elsewhere. It's just that we don't always get to see it.
On this particular morning, there was a lovely breeze, and we were there to see it.

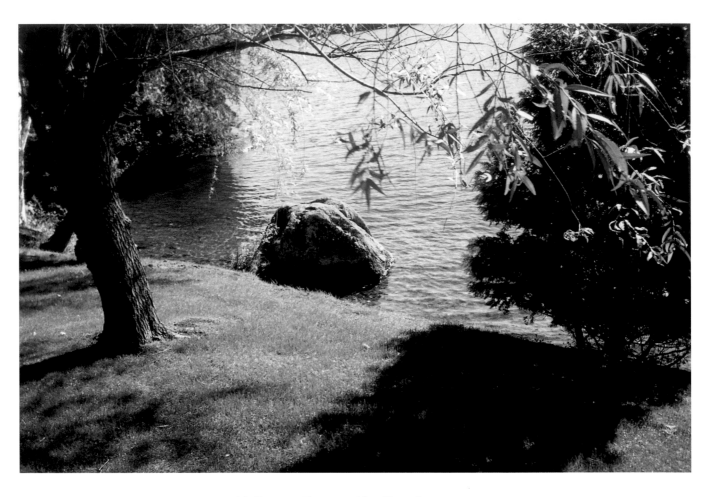

MY FAVORITE SARANAC, NEW YORK STATE, 1990

Somehow, this image always reminds me of Japan. There is a Zenlike quality in the droop of the willow tree and the placement of the rock.

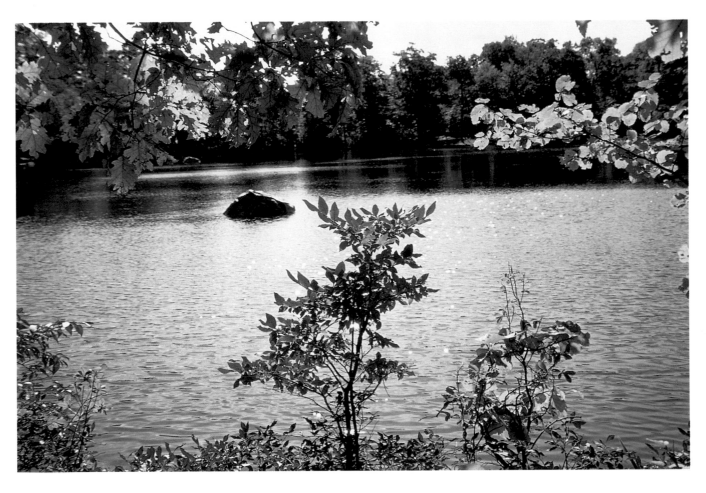

TRESPASSER'S WILL POND, NEW YORK STATE, 1992
The light coming through the leaves and on the surface of the water deserved to be recorded.

Overleaf: SUGAR MAPLE, U.S. NAVAL OBSERVATORY, WASHINGTON, D.C.
Before his swearing in as ambassador to Belgium, Alan Blinken and his wife, Melinda, were hosted at a luncheon given in their honor
by Vice President and Mrs. Gore. This beautiful tree stood guard outside the Gores' house at the U.S. Naval Observatory.

Overleaf inset: TRESPASSER'S WILL POND, NEW YORK STATE, AUTUMN, 1989
The water was very still, and the canoe glided easily around the pond that autumn day. The sky was cloudless and so blue, the eyes stung.

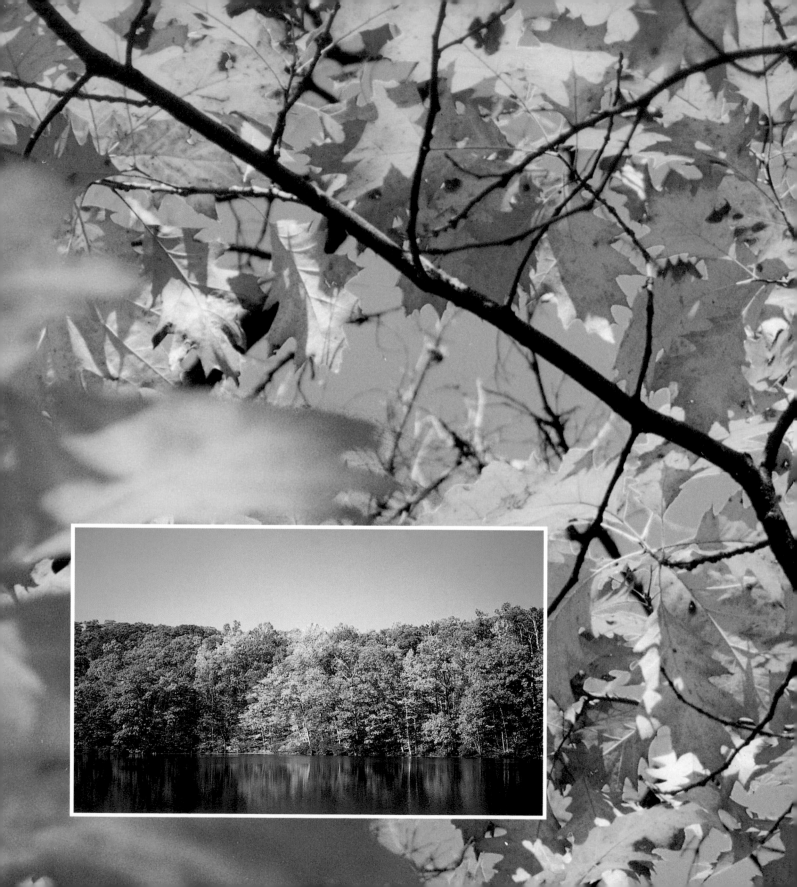

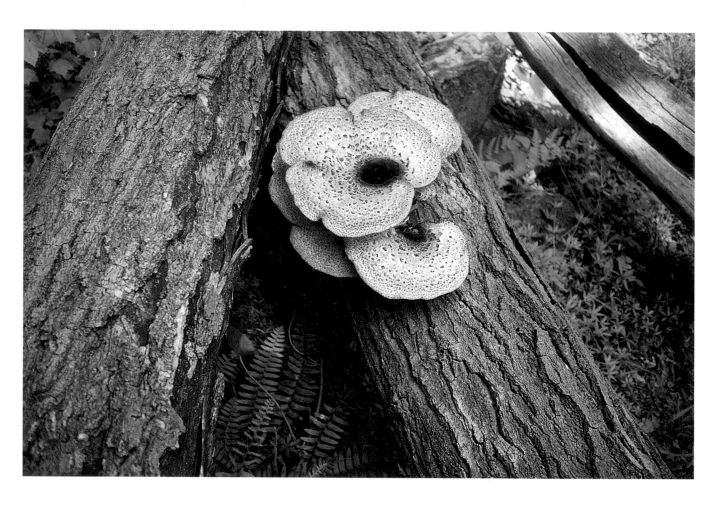

LOOKING AT YOU, NEW YORK STATE, 1989
These almost look like sunny-side-up eggs.

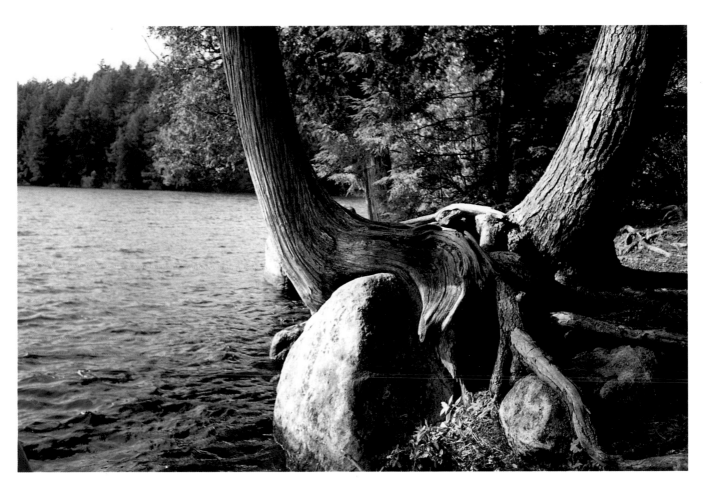

SEAL ON A ROCK, NEW YORK STATE, 1990

While picnicking with our children, I turned my head and saw this magnificent marriage of root and rock.
Because it was so close to the water, I almost heard the honking sound a seal makes.

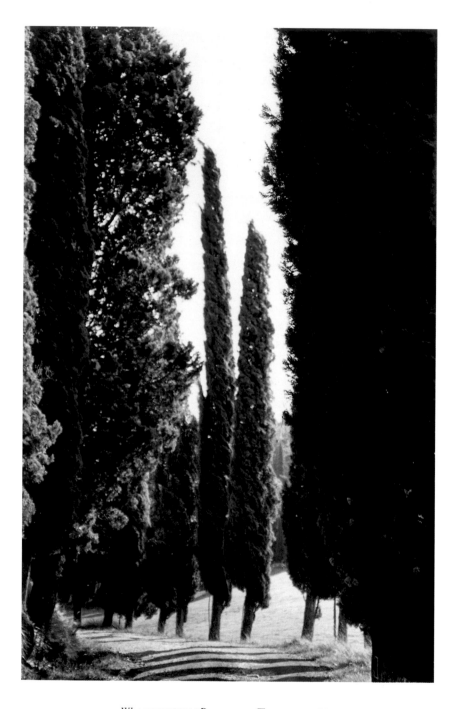

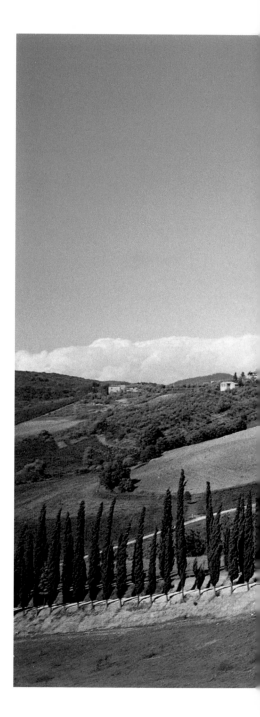

WALKING WITH RAYMOND, TUSCANY, 1992

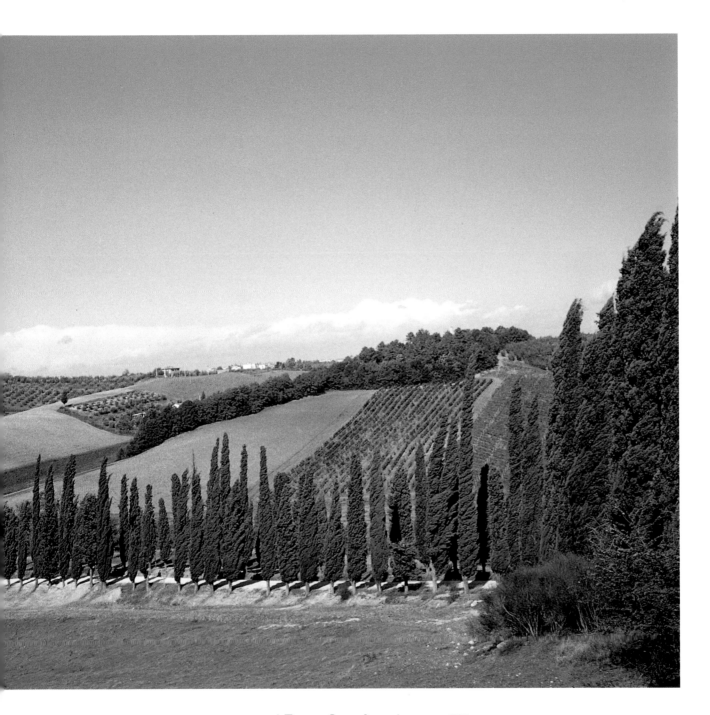

A Tuscan Road, Italy, Autumn, 1992

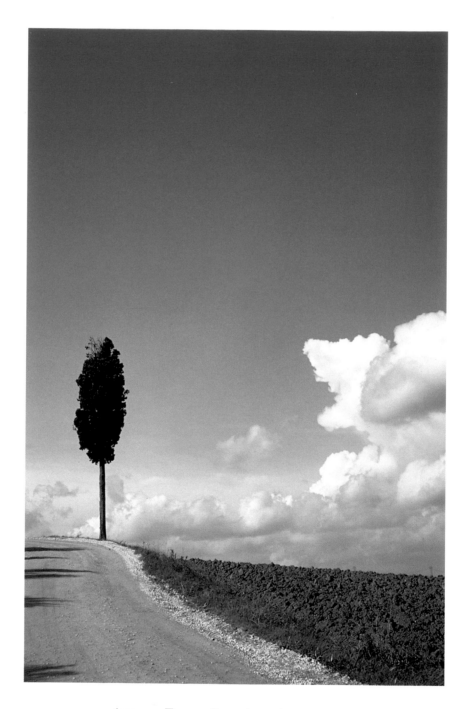

ANOTHER TUSCAN ROAD, ITALY, AUTUMN, 1992

Cypress Geometry, Tuscany, Autumn, 1992

TRESPASSER'S WILL POND,
NEW YORK STATE,
AUTUMN, 1991
*Capturing the colors formed by
the light on the leaves was easy
on such a brilliant day*

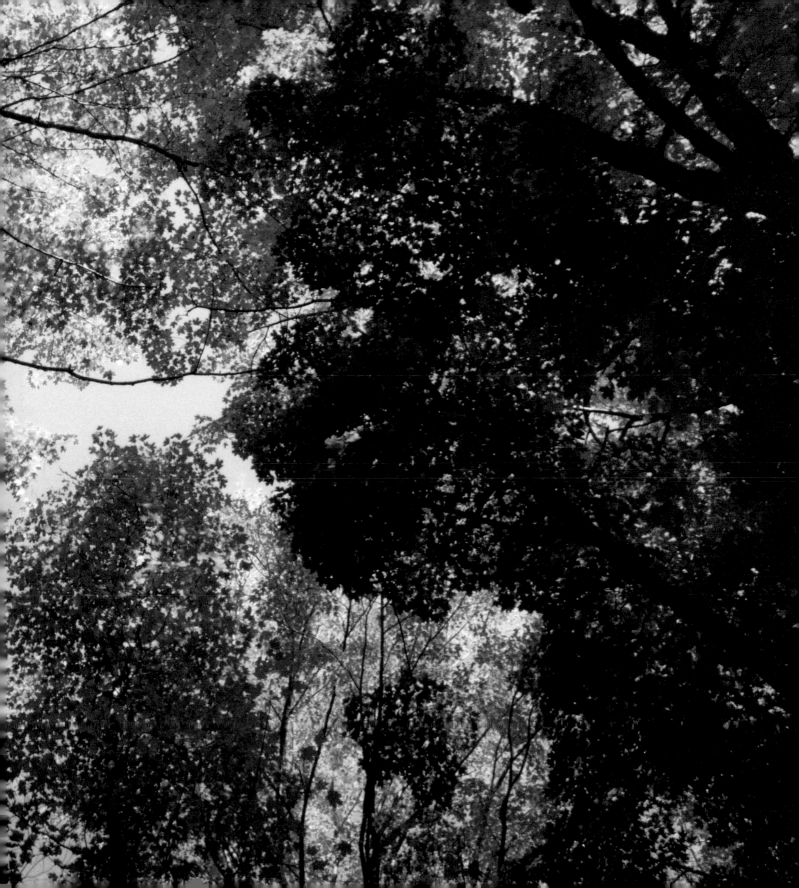